AMAZING SCULPTURE YOU CAN DO

AMAZING SCULPTURE YOU CAN DO

E. J. Gold

GATEWAYS BOOKS AND TAPES
NEVADA CITY, CALIFORNIA

Distributed by Gateways Books
P.O. Box 370
Nevada City, CA 95959
1-800-869-0658

http://www.idhhb.com
http://www.gatewaysbooksandtapes.com
ISBN Softcover: 978-0-89556-258-6

DEDICATED TO
RENZO FENCI
RUSSEL CANGIALOSI
AND
BOB GLOVER

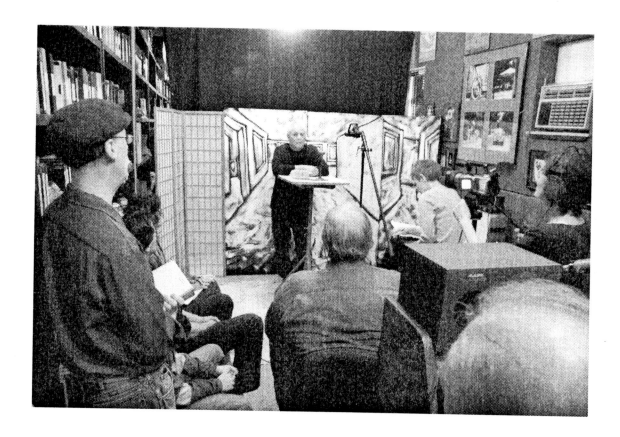

Welcome to my beginning sculpture class. I will share with you the results of over 60 years of sculpture experience and many secrets learned at Otis Art Institute under the tutelage of master sculptors Renzo Fenci, Russell Cangialosi and Bob Glover, to whom I dedicate this book.

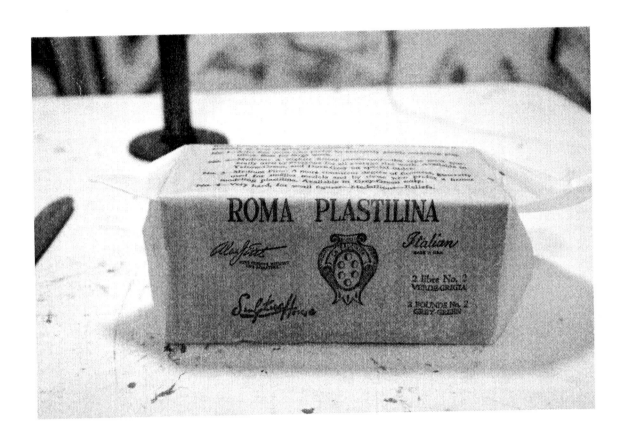

Not all sculpture is done with clay. You can sculpt out of a variety of materials. But for our learning purposes, clay is best.

For basic sculpture classes, we will be using Roma Plastilina grey-green #2. #6 is strictly for industrial design. It is very hard and stiff. #1 is too soft, and will not hold a good shape.

Roma Plastilina comes from Sculpture House. It's merely river clay probably from a tertiary channel. It comes in 2lb. blocks. It is not water based so it doesn't ever dry out as does ceramic clay. It will outlast you. It is made with mineral oil. The kind you use in the kitchen to clean butcher blocks, etc. It is wrapped in waxed paper. This is a 2lb. block of Roma Plastilina. This is how it comes to you. Be sure to unwrap it before use.

When I say sculpting clay, I only ever mean one kind of clay, Roma Plastilina #2 grey-green. When I say sculpture tool, I only mean one kind, The Tool, the 403A from Sculpture House.

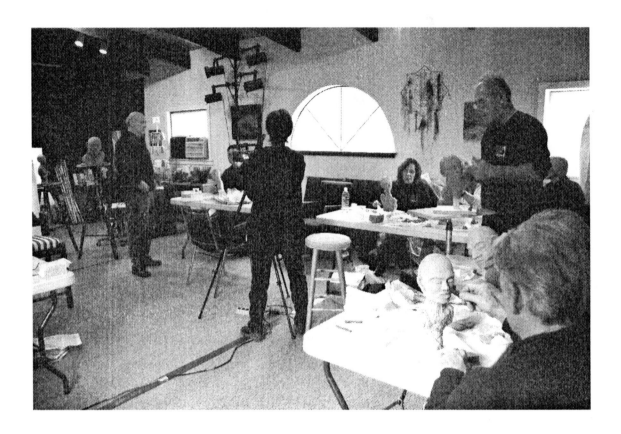

Sculpture has nothing to do with the instruments or tools. Your best tool/instrument is inside your brain case. It's where you get inspiration, ideas and observation. Observation is the best tool. It will tell you if your sculpture is going well.

Sculpture is the backbone of drawing. Drawing is the backbone of painting. Fundamentals really count in art, and a good foundational beginning is in the realm of working "in-the-round" with 3-D forms.

Sculpture differs from drawing and painting in that you can't depend on line to help you. Sculpture is three dimensional. It has a front, back, side and bottom. It has heighth, width, depth and mass.

A three dimensional form must be viewed as a mass or as a cluster of interpenetrating masses.

The block of clay comes to you as a single mass. A six sided polygon with surfaces, angles and interior mass.

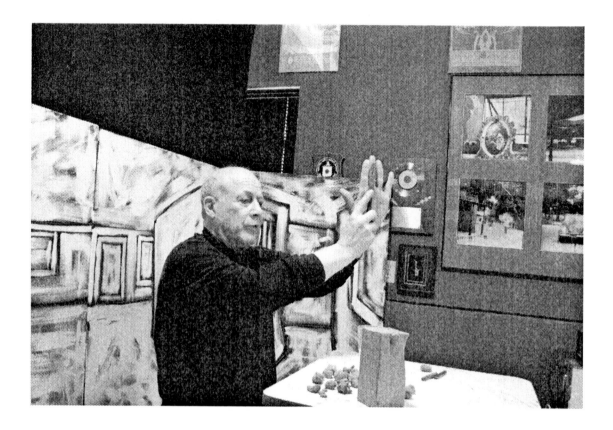

If you make sculpture by establishing and following an outline you will immediately proceed into error. Most beginning sculptors concentrate on surface. The surface is the last thing we deal with. In the casting process you lose most of the surface, so don't obsess over the surface of your sculpture, concentrate on establishing the basic masses and on simplifying the form. We will examine both those ideas in depth as we go.

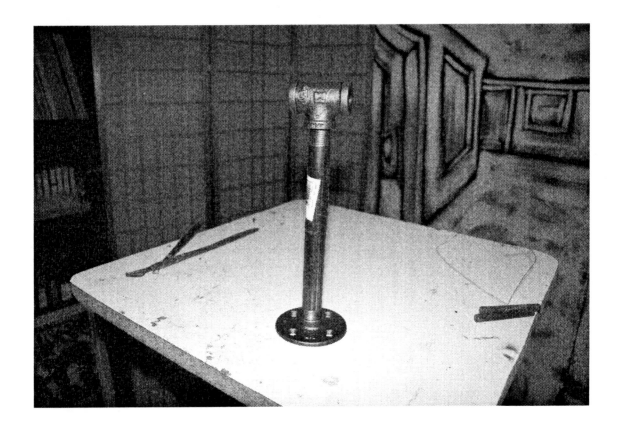

One type of homemade armature is made of black iron. The other type of homemade armature is made of galvanized iron. They are almost exactly alike. The black iron is cheaper. Use of PVC or ABS plastic piping is definitely not a good idea for a variety of reasons, but if you insist, go ahead and try them and you'll soon find out why.

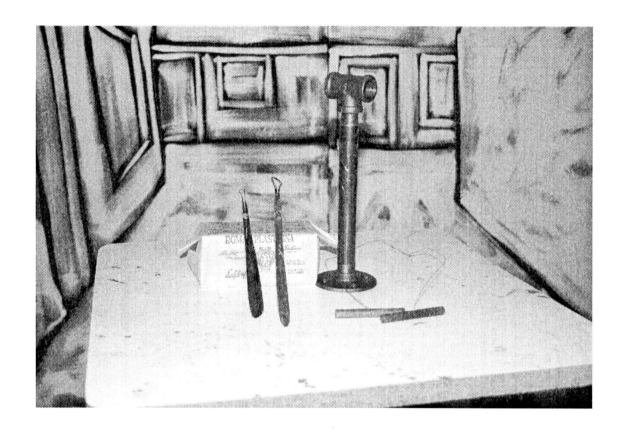

These items laid out here are your basic sculpture "allies" or tools. Roma Plastilina, The Tool which comes small to large with many new size options — 401A through 405A, cutting wire, armature and base, below all of which is on the rotating sculpture stand.

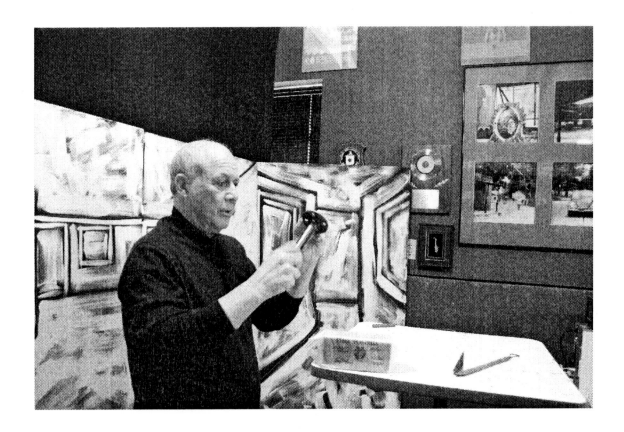

The homemade pipe armature is composed of four parts — an 8"x1/2" double threaded pipe, a flange, a tee or x, and a wooden base.

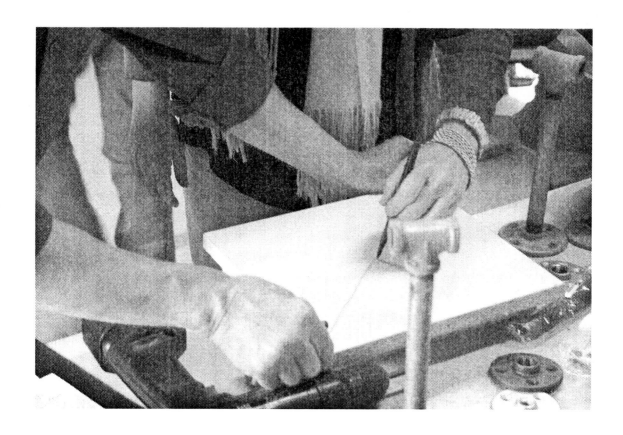

For the homemade armature and base, make an x from corner to corner on the base. The center of the x will be the center of your base.

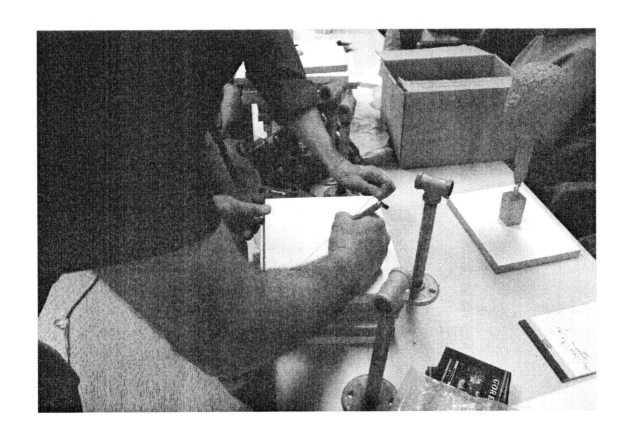

Use a marker to show where to drill the holes in the armature base.

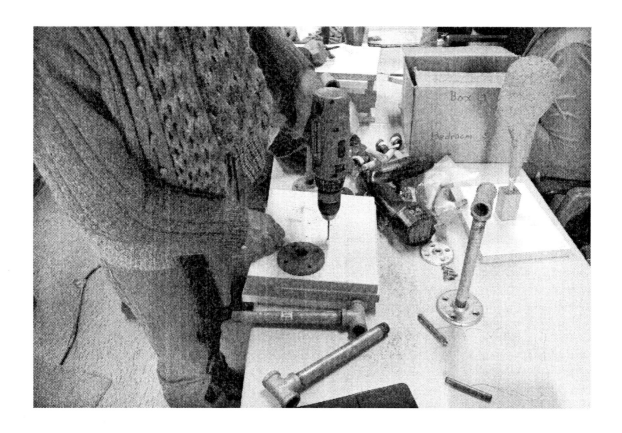

Line the center flange hole with the x on the center of your base. Then mark where the screw holes are.

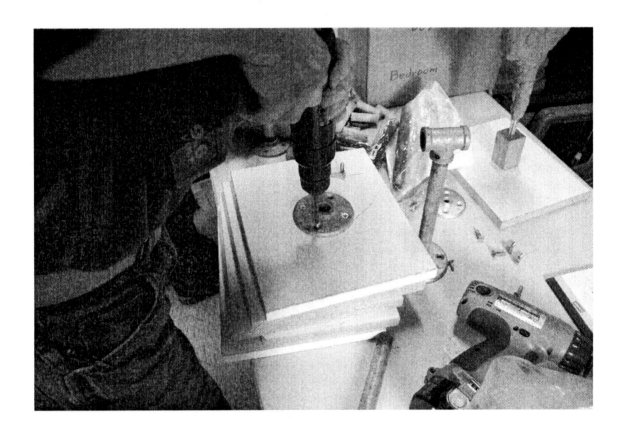

Screw the flange into the base with #8 3/4" wood screws.

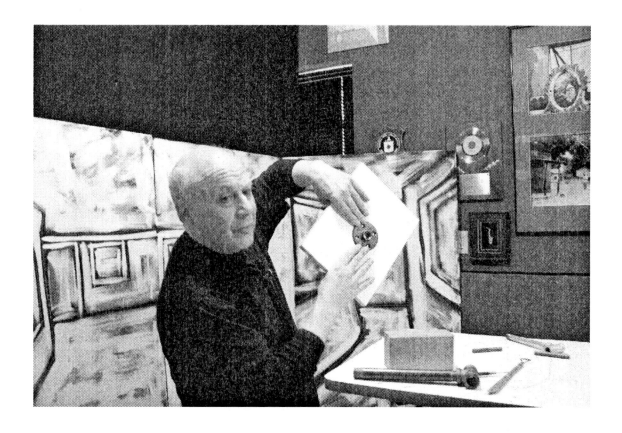

When you've screwed in the flange, your base and flange should look like this.

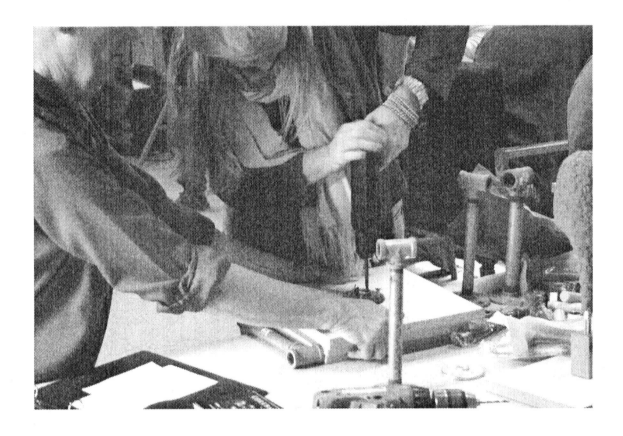

You can use a 1/4" drill for the purpose, with a 1/8" bit to pre-drill the hole about a half-inch into the formica-topped base. Then fit a phillips-head screwdriver into the drill and drive in the 4 #8 x 3/4" long countersunk wood screws until they are snugly fit, but not overdriven.

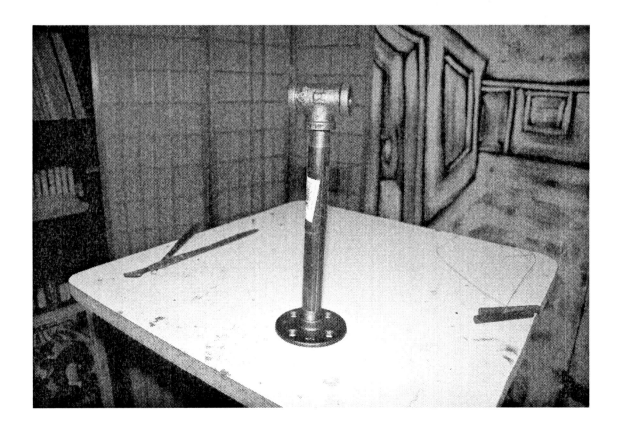

The base is fiberboard with arborite on the top. Don't use regular wood because it doesn't clean up well.

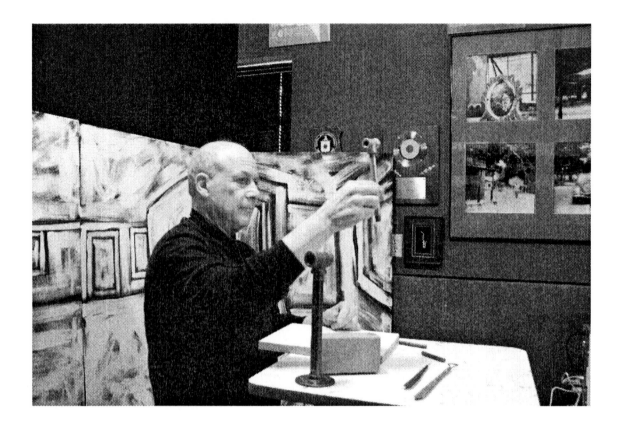

Your finished homemade pipe armature should look like the one on the stand.

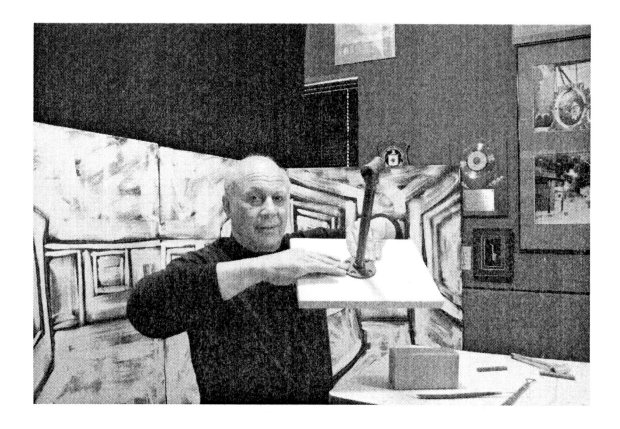

On http://www.ejgold.com/sculpture/armature you can see my online demonstration of how to put an armature together. These three plumbing items are all you need to make an armature. The parts of your armature consist of a flange, a tee or an x and an 8" x 1/2" pipe threaded both ends. They go together like this.

This will be your armature and base which goes onto your sclupture stand which you won't have or need in the beginning. I don't want you to have a closet full of tools you don't need. Wait for the sculpture stand until you are sure that you are serious about sculpture.

The armature is to sculpture what time is to the universe. Time is so that everything doesn't happen all at once. The armature is the backbone, the skeleton of your sculpture no matter what shape your sclupture is. There are many kinds of armatures or skeletons that you can use depending on the kind of sculpture you want.

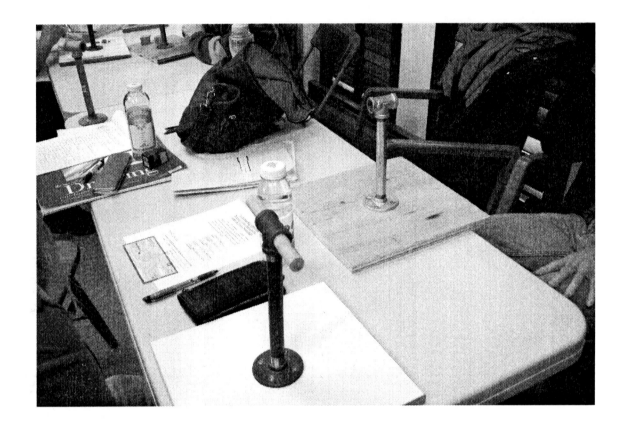

You can use wood dowels for shoulders if you like. Of course you can use a longer pipe for taller pieces, and add wood or more pipe and fittings to make any size or shape you might want.

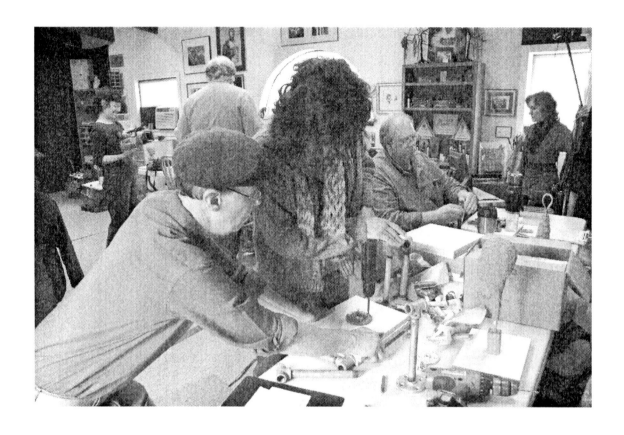

Students working to assemble their armatures.

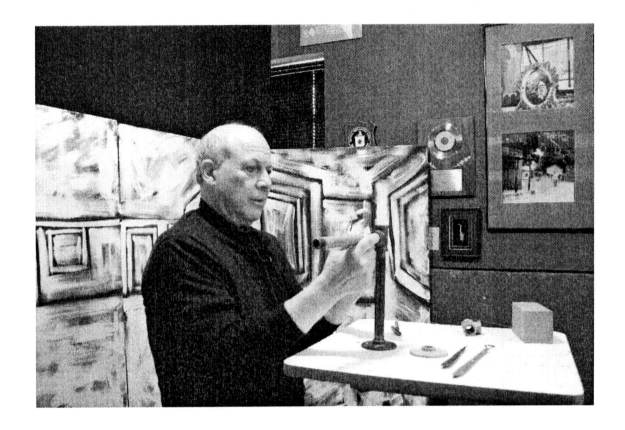

You can add pipe to change the form, but don't forget that in the case of undercuts or complex forms and masses, it must be chopped, cut or sawn off in order to make the mold, so you might want to consider a professional style wire armature if it's going to get cut apart. Pipe must be cut with a hacksaw.

Now you're ready to start sculpting a beginning head-form, but you might first want to know about professional commercial wire-built armatures.

Commercial aluminum-wire armatures are available through Sculpture House, and in the case of human or animal figures which must be cut up for the mold-making, are the only sensible way to go. In the case of complex figures, your wire armature will not survive, but replacements are available and relatively cheap.

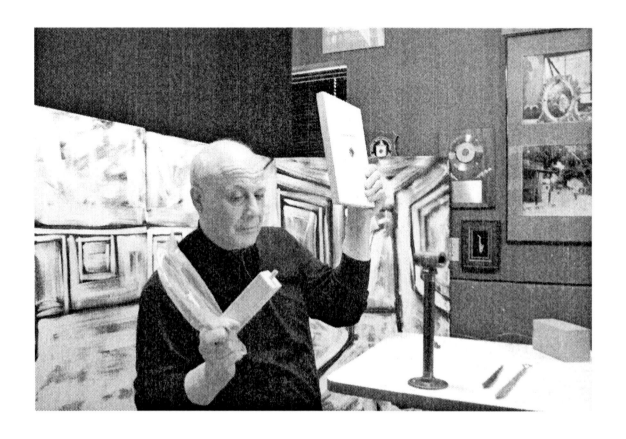

Putting the commercial armature together is as simple as A-B-C.

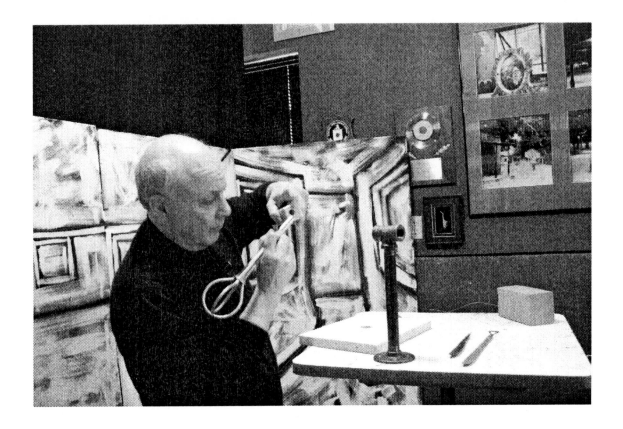

They are easy to assemble, and instructions come with the ones from Sculpture House — you'll find that unless you want a totally off-the-menu custom armature, Sculpture House ready-mades actually cost less than making them yourself, except for the simple head armatures. Thick aluminum wire and thinner wrapping wire plus hardware are all available from Sculpture House a-la-carte if you prefer to make your own custom-designed armature.

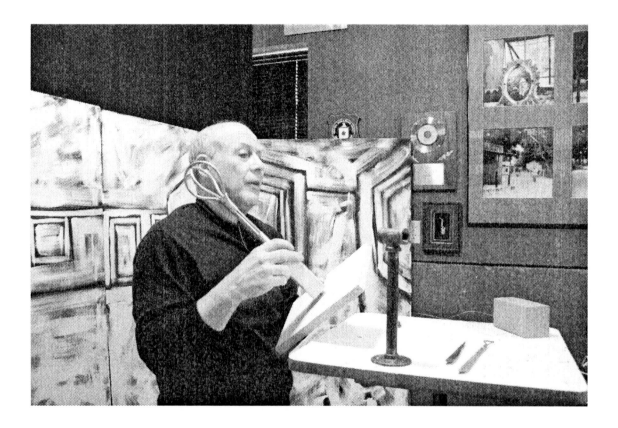

Screw the bust assembly onto its base if you are using the commercial Sculpture House head armature. Merely stick the wire head and neck assembly into the hole in the wooden attachment that carries the base screw. Instructions for assembly are in the box if you get lost, or watch my video demo on http://www.ejgold.com/sculpture/armature.

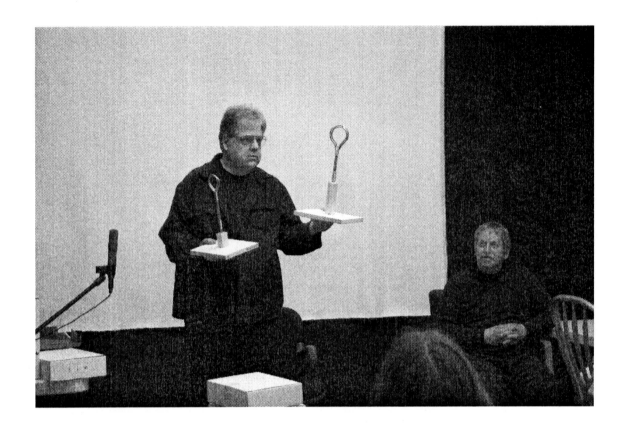

Famous world-class sculptor Claude Needham is holding up two different sizes of commercial armatures, 15" and 18", which are available from Sculpture House. They come unassembled with a base, but are very easy to put together in just a few moments.

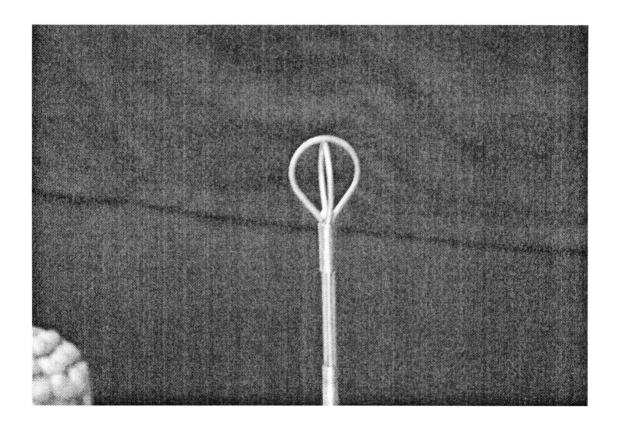

The commercial wire head armature comes flat. You must turn one of the loops to make it round, like this. Then it is ready for loading.

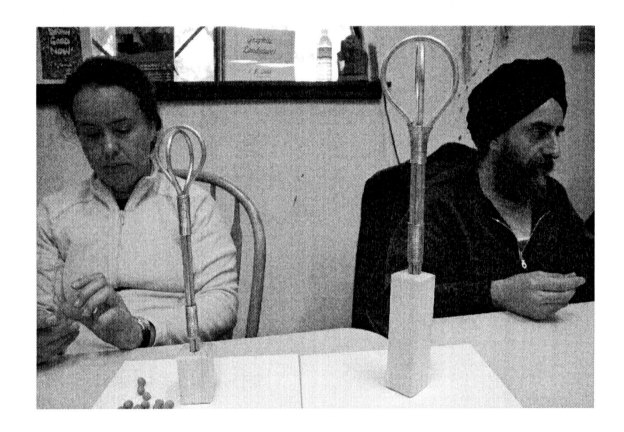

The smaller variety of commercial head armature might be easier to begin with. It will use less clay, and be used easily on a table or workbench until you decide on and work with a sculpture stand.

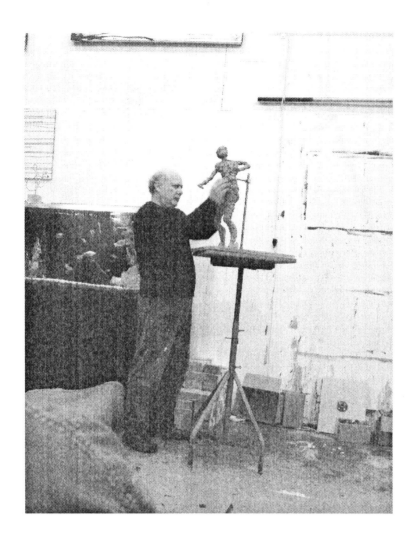

There are also figure armatures for about $35.00 to $100.00 depending on complexity, size, quality and strength, variability and ease of replacement following the "foundry chop". This one is the 24" armature on my Hercules stand.

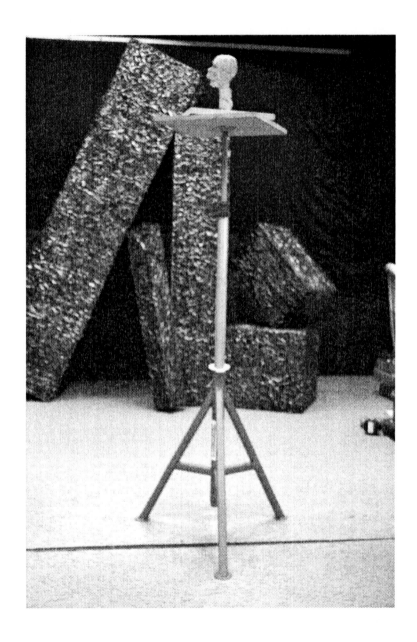

My little Hercules stand, is the stand of choice and costs about $250. It has little adjustments so that it will stay completely balanced and you can raise and lower the height as you wish. You can work down onto your sculpture from above or you can work up to your sculpture from below depending upon how you want to work. However, this homemade student stand which cost $90.00 to build will do quite well for small work.

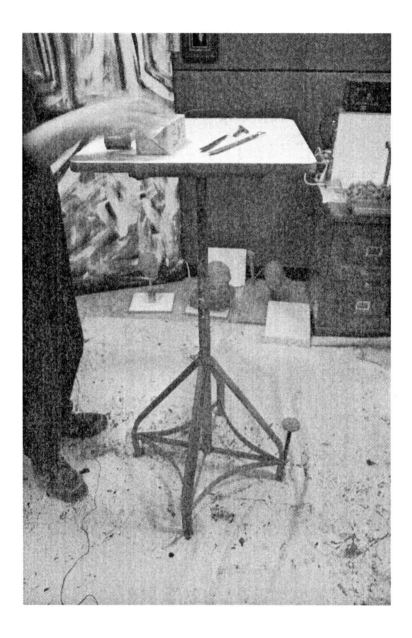

This Little Hercules sculpture stand will turn smoothly and comfortably, and you need it to turn because you're going to be constantly turning your sculptural form. You're not going to stop turning it, because you're always working "in the round" like theater-in-the-round. If you're going to start working on big pieces, you're going to want a sculpture stand. And you want to have a concrete floor and to avoid tracking clay all over the house you want to have a pair of shoes just for the sculpture area, and then get out of those studio-only shoes before you walk around the house. You want a special pair of shoes just for your sculpture area.

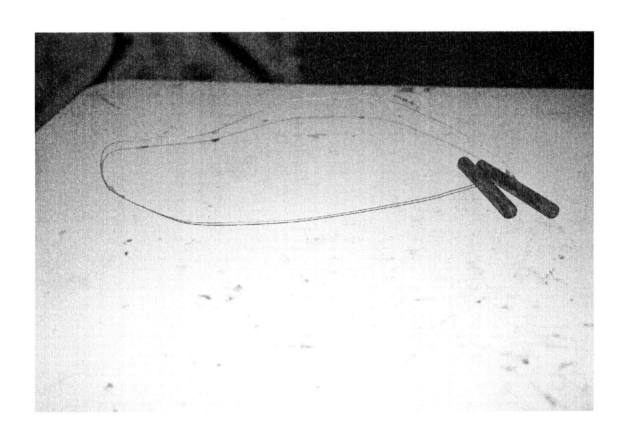

This is a wire cutter; you use this to cut large clay blocks. It's called a wire cutter because it's made of a piece of wire that is strung between two dowels. We use it to cut clay. The kind I like costs around $9.00 from Sculpture House in New Jersey.

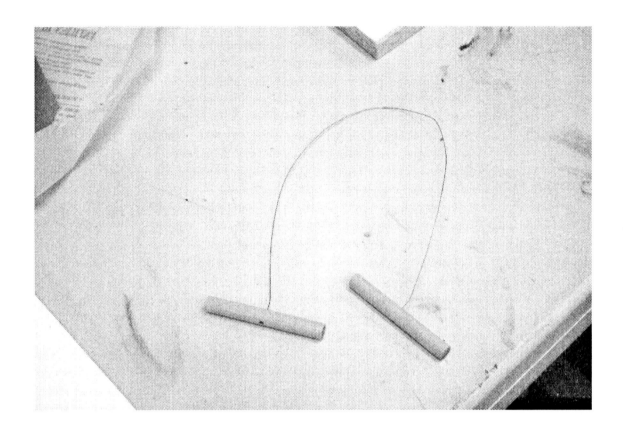

Here is a homemade guitar "E" string or a piano-wire cutter to cut the clay brick into smaller more manageable chunks. Never use The Tool, meaning your wood tool, to chop big pieces of clay.

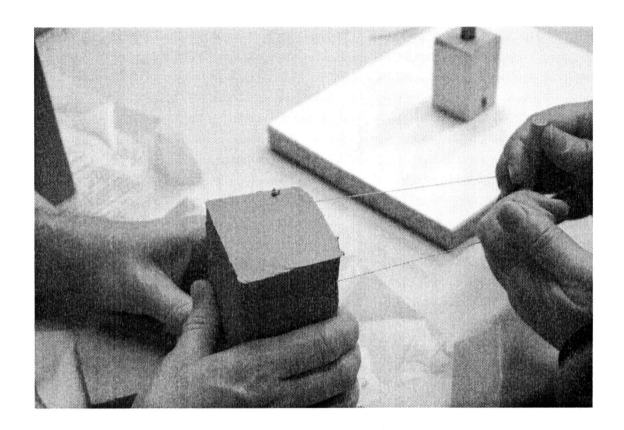

Clay is what you call mud, the kind you step in in crossing a stream. They reduce it with heat, take out the water and replace the water with mineral oil to make Roma Plastilina, the professional sculptor's choice for modeling sculpture. Building a sculpture out of clay is correctly called "modeling". It has nothing to do with someone posing on a model stand.

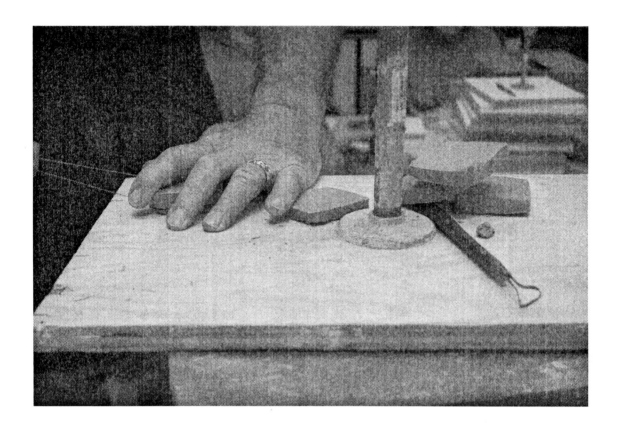

Begin by slicing off 3/8" slabs from the larger block of Roma Plastilina with your double-handled wire tool.

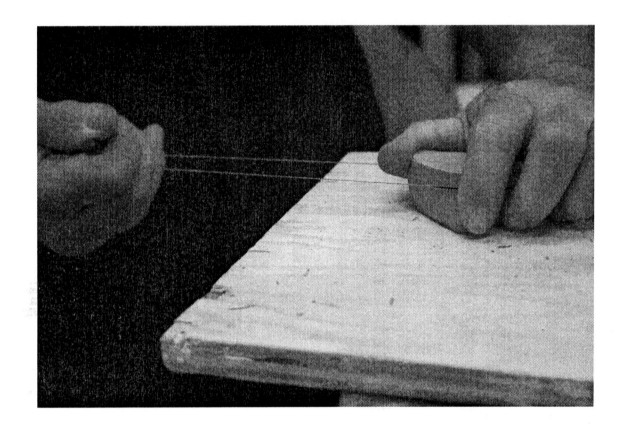

Soft clay will load best onto your armature. Hard clay won't stick to either the metal armature or to the larger body of clay. Your job now is to make the big hard brick of Plastilina into small soft blobs of useable clay.

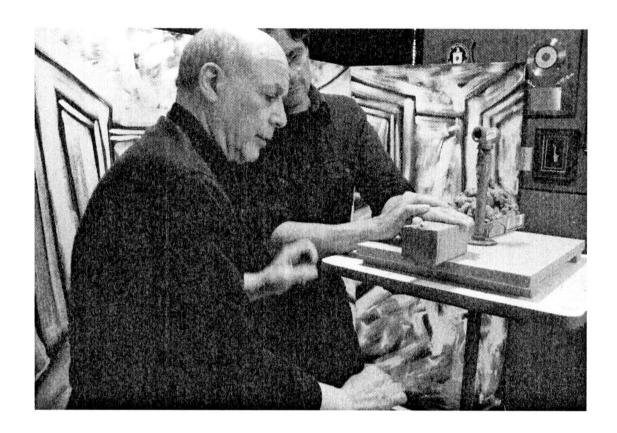

Cutting the slab into smaller pieces might require help from a friend, neighbor or fellow artist. You'll soon find that sharing a studio has many advantages, including sharing the model fees, shipping costs and helping each other with heavy objects.

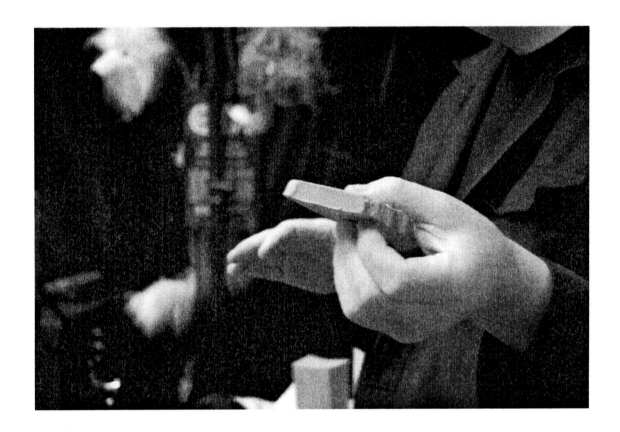

This is about the right thickness of a slab cut. Note that it's best to cut the brick on the short side, not lengthwise.

You're starting to get into body contact with the clay, to actually get into one-to-one relationship with the medium to have a tactile relationship with the clay and a tactile relationship with the armature. That is very important because actually sculpture is a tactile art. You can't get any more hands-on than sculpture except, perhaps, in turned or built pottery or in the form of finger painting. It's as close as you can get to the actual stuff. It's very important that you establish a tactile relationship with the clay. This realization is very important.

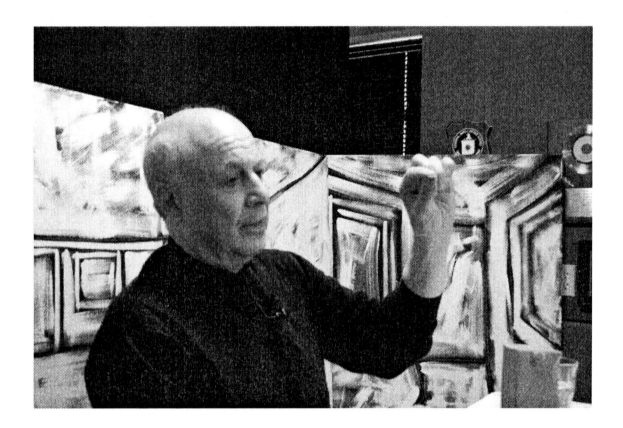

If your clay falls on the floor, it is easy to pick up if you do it right away. You just have to know that you dropped it, which requires some attention, and you have to pick it up which requires a minimal of non-laziness or the ability to look into the future and imagine what will surely be the messy and annoying result after it has been on the floor and someone has rubbed it in thoroughly and unremovably.

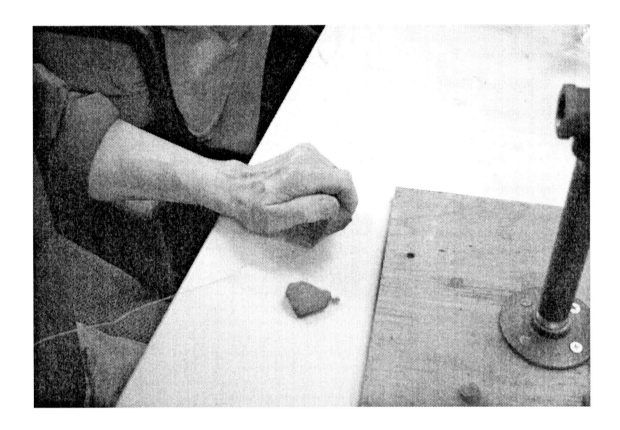

Break off smaller pieces from the cut slabs. Soften smaller pieces. Enjoy loading the armature with your hands while you can. Later you will use only your tool to apply the Plastilina to the loaded armature.

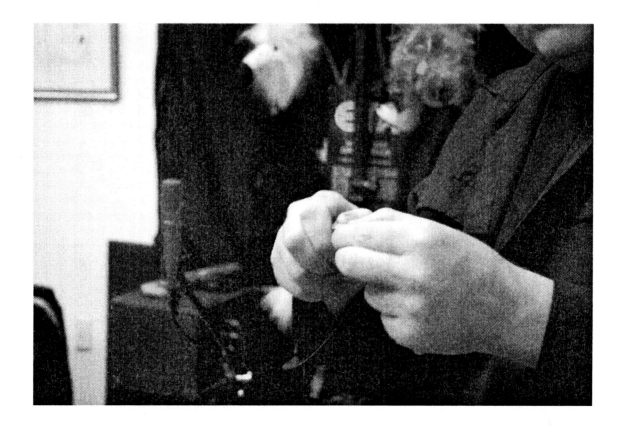

The Roma Plastilina must be well-kneaded to the consistency of recently-chewed chewing gum. You will feel heat from it when it is ready to use.

Start with little blobs, about the size of a garbanzo bean or large garden pea.

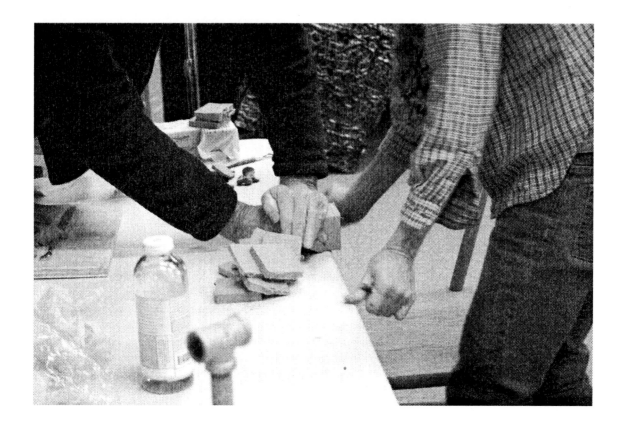

Clay gets used over and over again. You can add mineral oil or add new clay to old clay to make old clay soft. The Plastilina will easily outlast several dozen generations of sculptors.

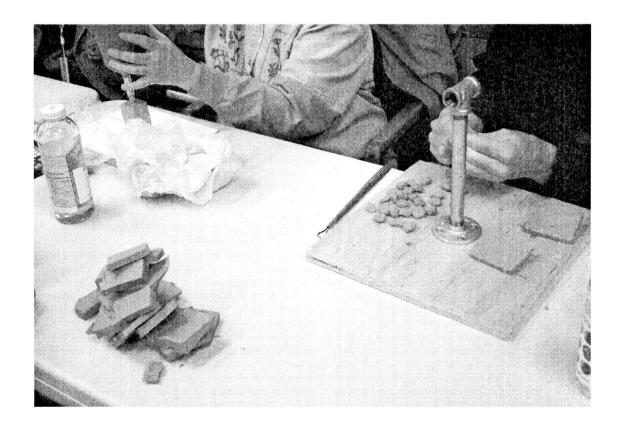

You must refresh your Roma Plastilina slightly every time it comes back from the foundry, because it will come back full of mold-release, similar to your baby or mineral oil, which must be worked in by kneading. It may have dried out somewhat if the foundry has had it in a hot, dry environment for several months or a year if they've gotten backed-up on their pours, which does happen when a worker gets sick or injured.

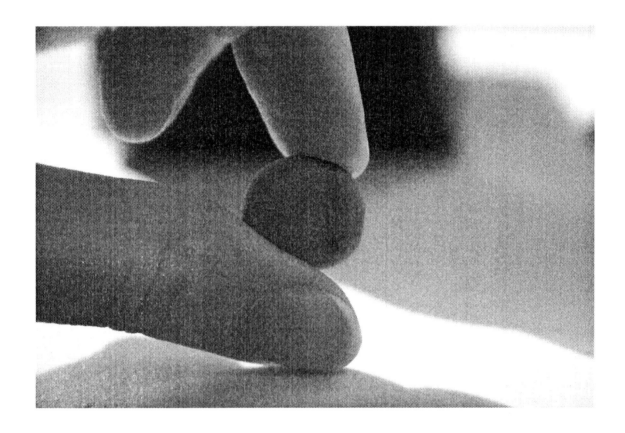

Part of the lump I originally got from Renzo Fenci has over many years been thoroughly worked into each piece of clay I use today. That clay goes back to the Renaissance sculptors in his 450 year lineage. I give my professional students here at The Blueline Academy a lump of my decades-old Plastilina and you mix this into your clay and then someday you can pass this on when you have students of your own, thus preserving the lineage.

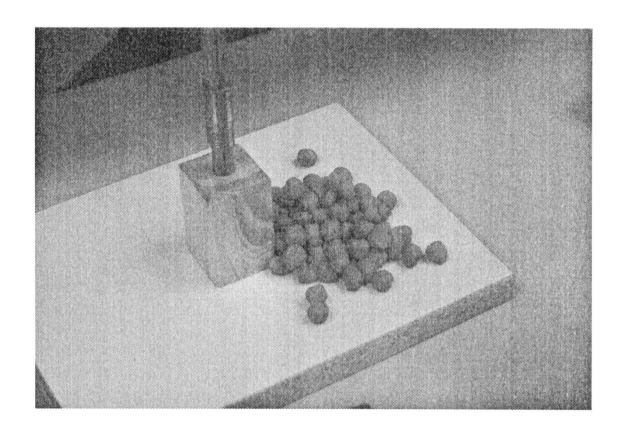

You will need many hundreds of little lumps of Plastilina the size of garbanzo beans or large garden peas — flattened garden peas — somewhat flat, not tightly compressed, just a bit on the flattish side — 1/6" to 1/8" thick by about 1/2", which in metrics would be 3 or 4 mm by 1 cm wide. We have covered most of what you need to start.

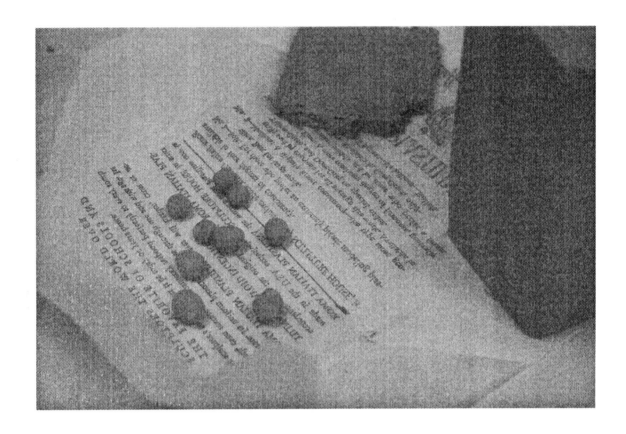

These little bits are very valuable. They easily squish into tiny blobs that are warm and soft.

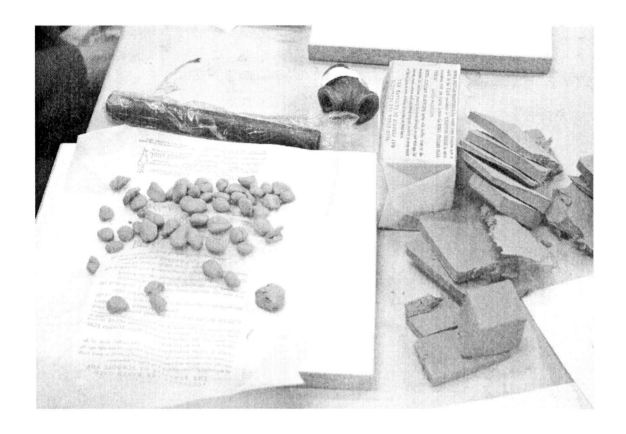

Resist putting the clay bits onto the sculpture with your finger unless you are specifically loading the armature.

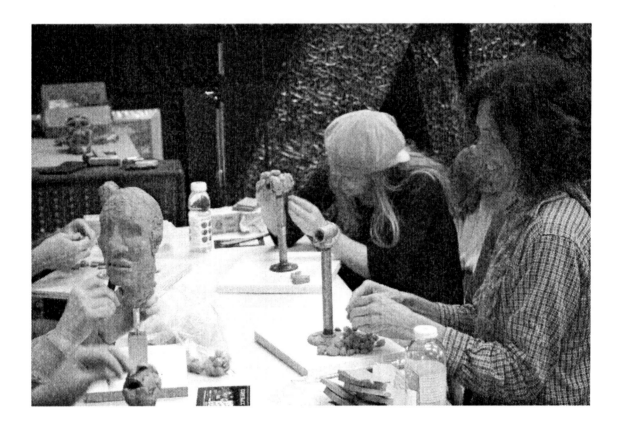

The only time you are premitted to use your thumbs directly on the clay is when you load the armature, which is long before the detailing takes place. If you have to ask at what point that is, it's time to start using The Tool.

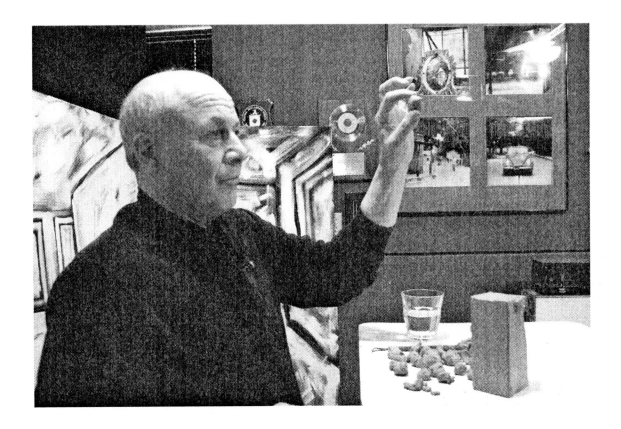

When you're working with oil paint, you're constantly working with poisons. The poison is in the turpentine and the Damar Varnish. The third element in the mix is linseed oil, which is when not in combination with Damar Varnish and/or turpentine, actually digestible. It's also called flaxseed oil. Another oil that's used commonly in painting and sculpture is mineral oil. Mineral oil is also known as baby oil. And it is also digestible except it shouldn't be given to small children because they can inhale it. If you swallow it, you're fine, it'll go right through the system, but if you inhale it, it goes into the lungs, even the slightest bit, and it's cumulative, and it never leaves the lungs. So you don't want to actually take it internally; there are better laxatives than mineral oil, but it is still used for that purpose. Topcare Extra Heavy Mineral Oil Lubricant Laxative — tasteless, colorless, odorless is useful if your plastilina gets too dry. But don't add too much, and don't actually take any art supply internally!!!

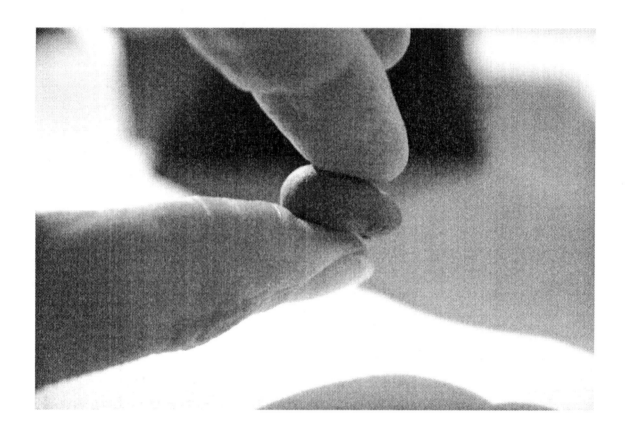

Kneading small pieces is the tried and true way of softening the clay and making the small additive lumps you will use to build with. It develops good hand strength and gets you into direct immediate intimate contact with the clay.

As you are working with these little tiny clay pellets, remember that each pellet is a universe and you are warming that universe, you are putting soul, life into that little tiny pellet. You are warming that piece, giving it life. Like Dr. Frankenstein, you are actually giving your life force to the clay, which is a great sacrifice. You are giving some part of your life to that clay.

Think of the clay as your own body which is coming to life and forming a little pile here ready to work. So you really have nothing but yourself with which to make the world. Take responsibility for what you are making, a three-dimensional Vision in the Void.

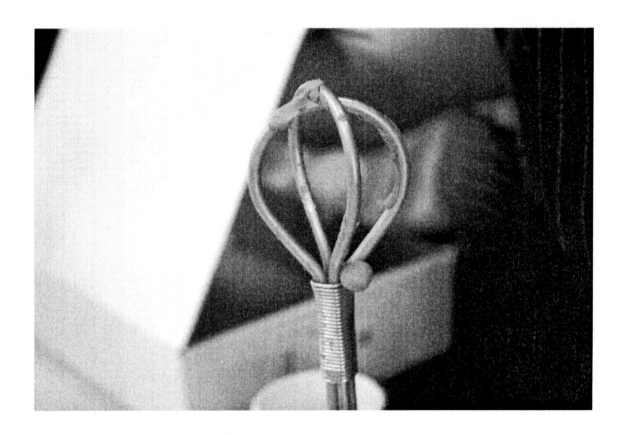

Closeup of the wire head armature at the very beginning of the loading proceudre. Note the tiny size of the warmed-up clay balls being applied.

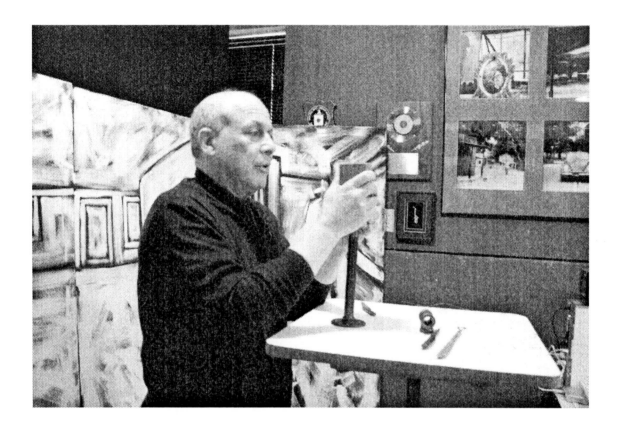

Why do we not just cram the block of clay onto the armature? Because it would turn constantly and crack open and just plain fall off during the mold-making process, or long before. The clay must be "loaded" slowly and carefully onto the armature a little pellet at a time.

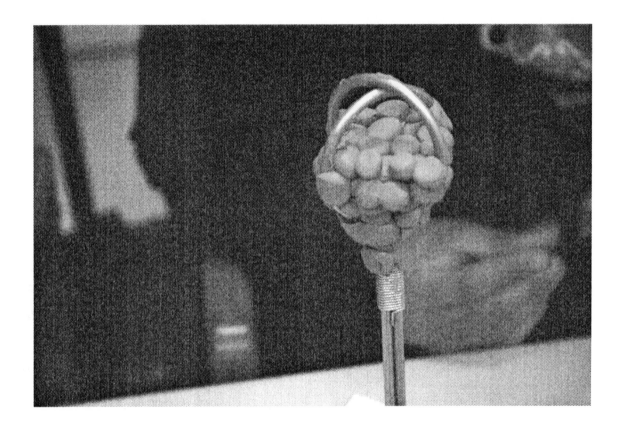

This is a little tiny armature — I loaded these clay pellets on it, which took me about an hour to load up correctly. What I'm going to be showing you about clay modeling is Italian style sculpture, which I learned from Renzo Fenci, Russell Cangialosi and Bob Glover, three of the foremost sculptors of the 20th century.

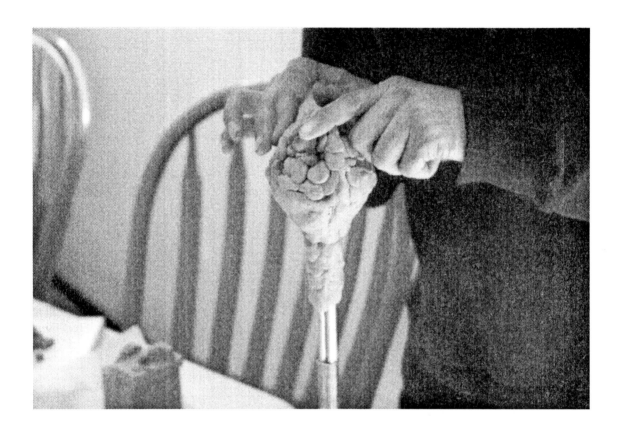

Use fingers, thumbs, palm while you can. Once the armature is loaded, you may not use the hand to move or press or smear the clay!

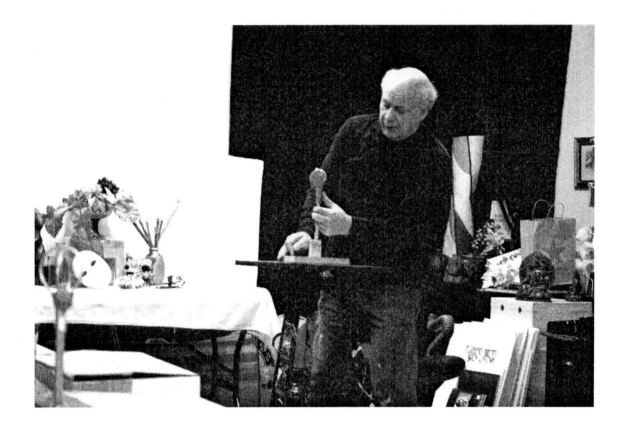

Loading the head armature a little at a time is the best way to avoid splitting and cracking disasters later on. This is the only time we will use our fingers to put clay on the armature. Once the basic form and masses have been established, we will use "The Tool" exclusively. Don't cheat this later on — you'll be sorry you did!

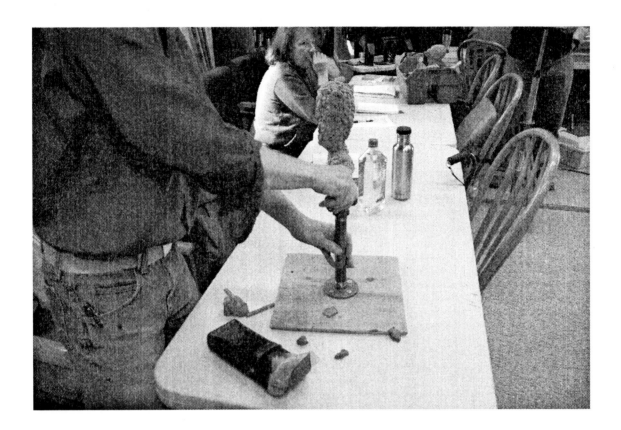

How you load the armature up is very important . . . You take a small piece and lay it in with your thumb, and then another piece and lay it in and another and another and another. You're not going to smooth it out. Just resist the urge. You will want to smooth it out, spread it around like butter. Resist the urge to do that. Just push it onto the armature with your thumb and let it stick. It's very important that you do that. Correctly loading an armature is 90% of what you're going to do as a sculptor. Don't smooth, smooth, smooth. If you smooth it out, it's going to be all wrong unless you're attending an elective sculpture class at a Junior or City College. Simply dab it on and let it sit. When you start working with your sculpture tool, it's 99% important that you learn to just put the pellet on there and resist the urge to smear it.

And remember, sculpture is a meditation. Don't forget to breathe.

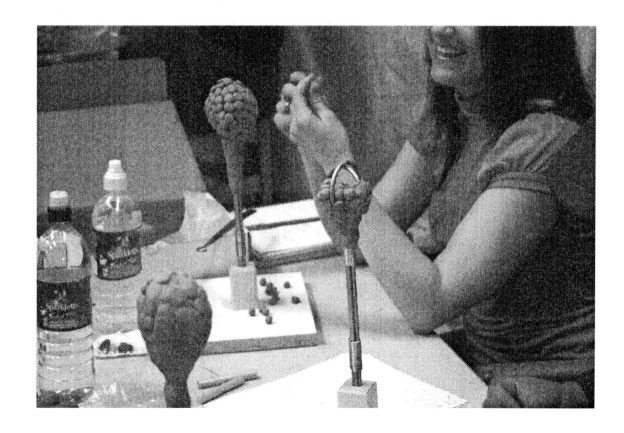

On a beginning head you are making only a head and neck. It takes less clay. Later we will add the rest of a complete sculptural bust, the neck, shoulders, chest and back.

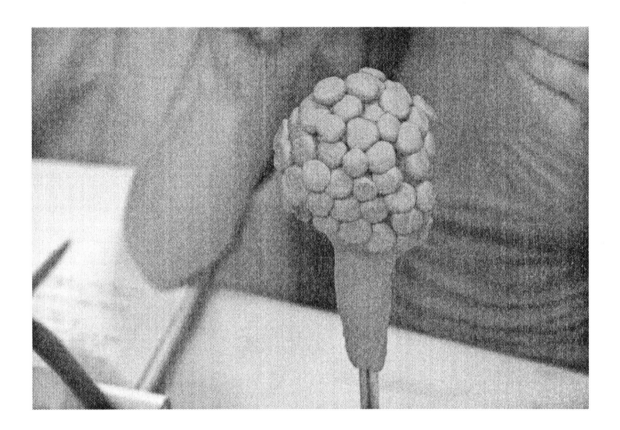

At this point you are not interested in the surface of the piece. You are interested in only the simple pure form which is composed of interpenetrating masses.

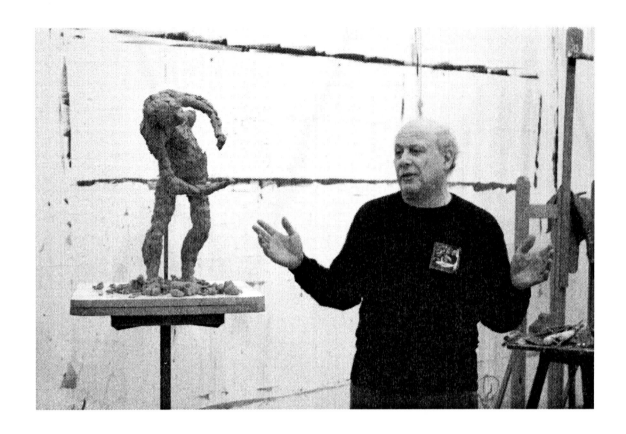

I use this piece as an example. It is correctly loaded. It's a figure. It is what is called "roughed out". Most sculptors today would be happy to turn this into a foundry and be done with it, but that's not what I would call a finished piece. I can rough it out in an hour, but it might take me as much as a year to finish it.

Ignorant buyers think that a rough sculpture is the greatest coolest thing, because they've been taught to think that because that's the way the market runs and the average sculptor can do no more than this. I'm going to show you how to get it to the point where Michelangelo could take it. Now if you, at some point, want to make sculpture that looks like this, it's up to you. But if you really enjoy sculpting, you don't want to just leave it rough and unfinished. You're going to work to finish off all of those areas that are unsolved.

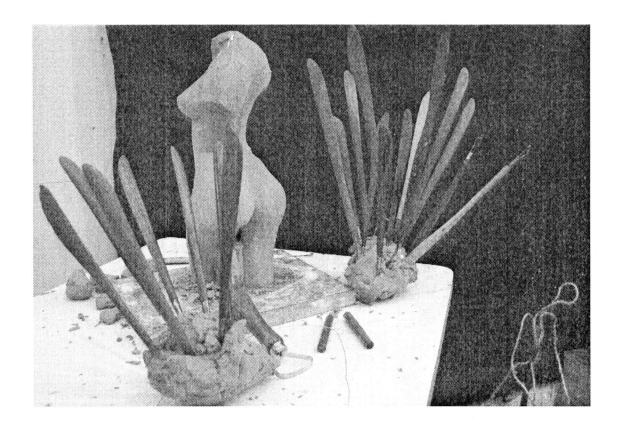

We have not yet talked about The Tool. That's how we referred to it at Otis Art Institute. The Tool was developed by Renzo Fenci. Fenci had the distinction of making sculpture in the sports Coliseum in Rome and later for the WPA during the Great Depression of 1929. In the old days, we made our own because they were not yet commercially available, but now they are.

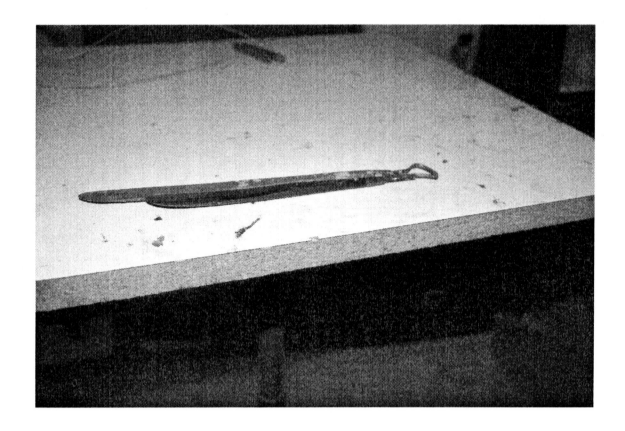

We made our own sculpture tools of rosewood, teak, ebony, cocabola, lignum vita almost any hard-wood. Rosewood really is a great wood to use for this purpose. You have to craft this out of a piece that is approximately one inch by half inch, and then you turn it and shape it, and then at one end there's a brass cutter which is serrated on one side and flat on the other.

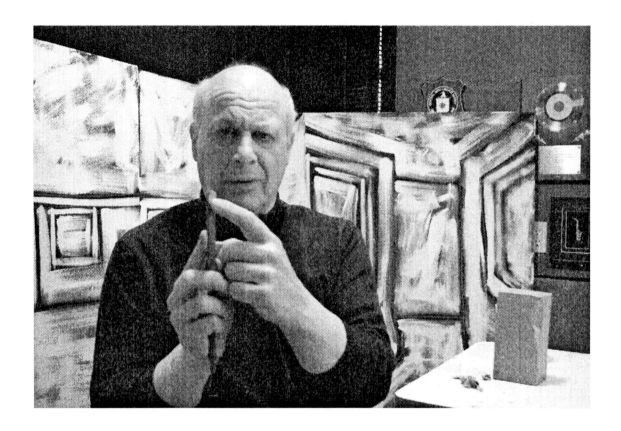

The Tool is slightly curved on the flat side — feather shaped, and very curved on the outside. Never use The Tool to cut clay. There is no reason for your tool to break other than sheer ineptitude or heavy-handedness. The Tool is made of Brazilian hardwood. The man who made them passed away a year ago. His widow trained an artisan to do them and he is able to produce these in the original way. Every tool is slightly different — they are handmade.

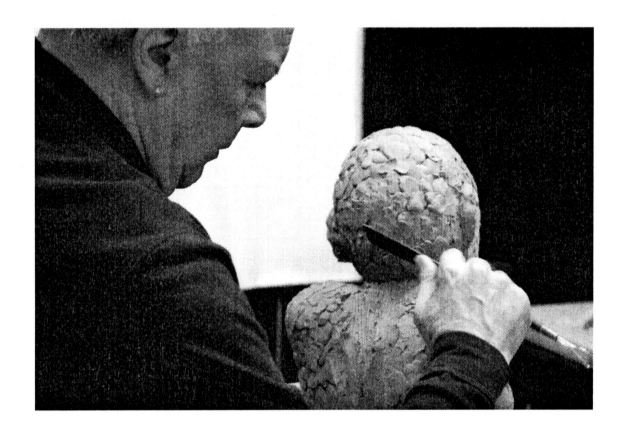

You will learn the tool's idiosyncrasies and it will learn yours.

Actually this tool becomes part of your body. It will grow into your hand.

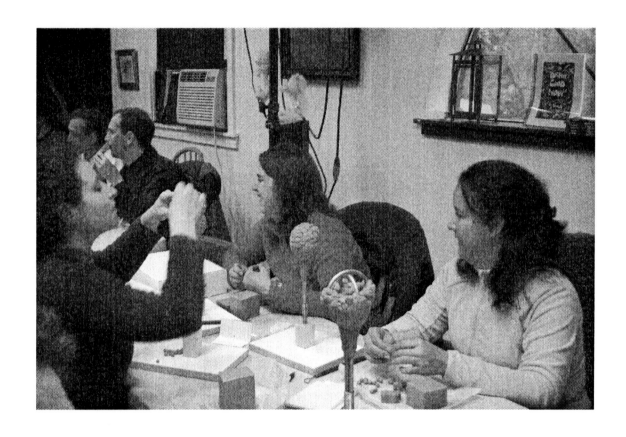

Start placing clay with The Tool. Do not smear.

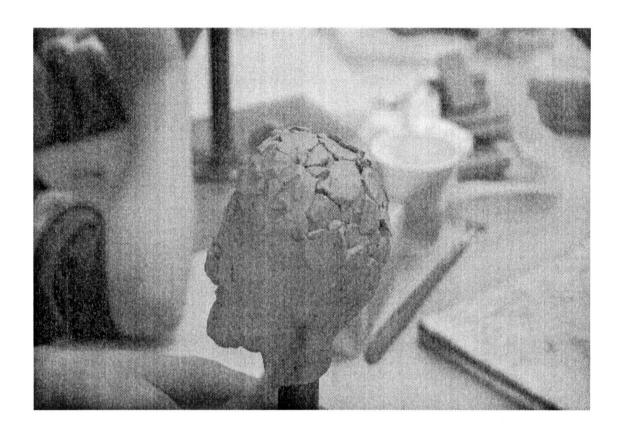

Tack the clay onto the main body of clay only with The Tool.

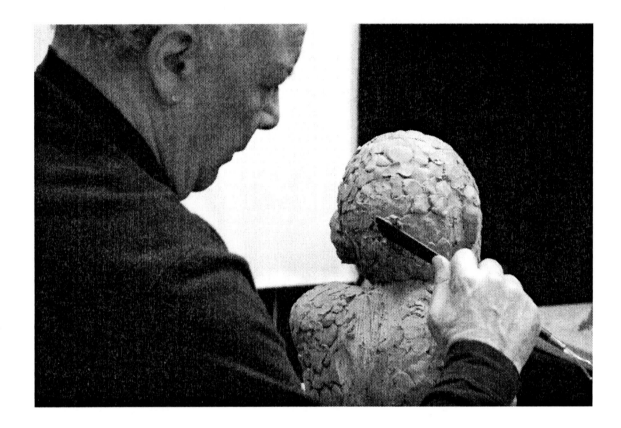

The most important thing that you can ever learn from me about sculpture is what I learned from Renzo Fenci, the most important thing, the thing that he held to be the most important thing is always use the tool. Use your fingers only for the initial loading of the armature and to soften the clay.

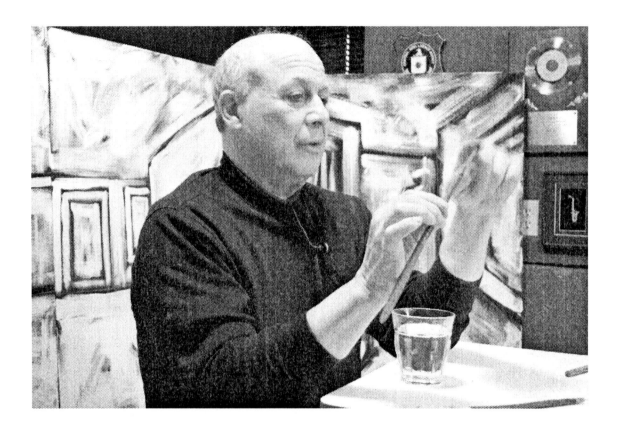

There are many professional sculptors who cannot imagine sculpting without The Tool. It is the only tool you will ever need. It incorporates the features of dozens of tools into one single tool. It also allows you to change "put" and "take" modes without having to stop to switch tools!

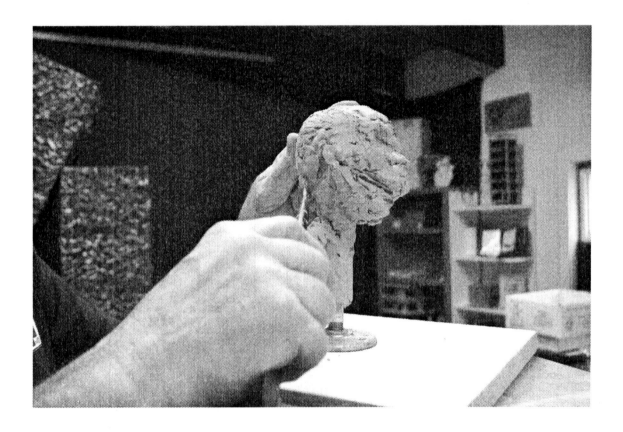

This is the 403A from Sculpture House, my personal preference for most sculptures. I use a larger similar tool on 5 and 6 foot tall life-size pieces.

There are several different sizes of this tool, from tiny to quite large. This variety of sizes is quite new. You might want to order one of each while you can. Handmade custom tools seldom last long on the market, and we almost lost permanently the one-and-only Brazilian source for The Tool!

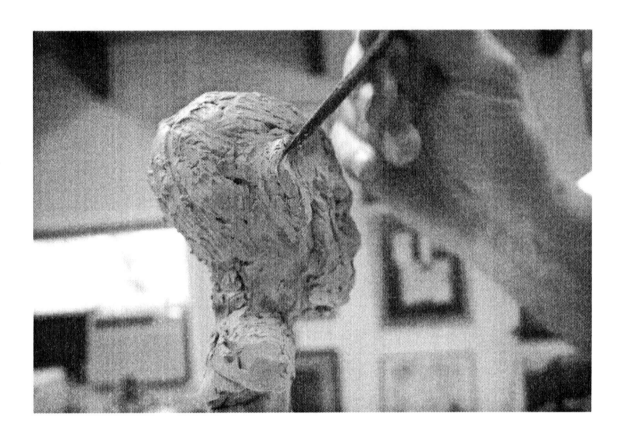

It is a strong tool and becomes part of your hand.

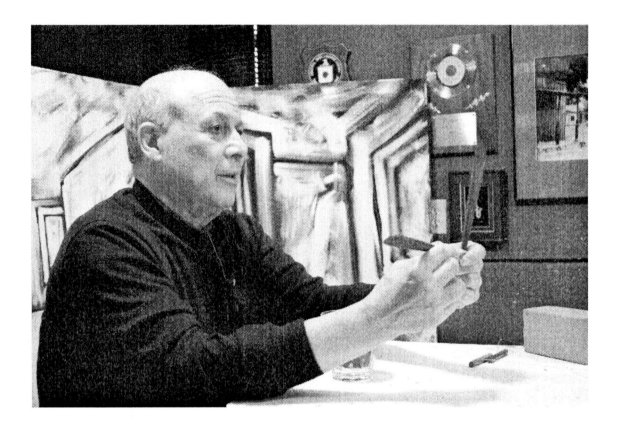

How to hold The Tool.

This is one method: Using the thumb on the flatter side in such a way so you don't hold the metal at the bottom of the tool.

There is a balance point of your tool in the same way there is with a foil in fencing, a baseball bat or tennis racquet. It becomes a part of your hand. It's a balancing act and you will learn how to juggle your tool. Think of it as a fencing foil.

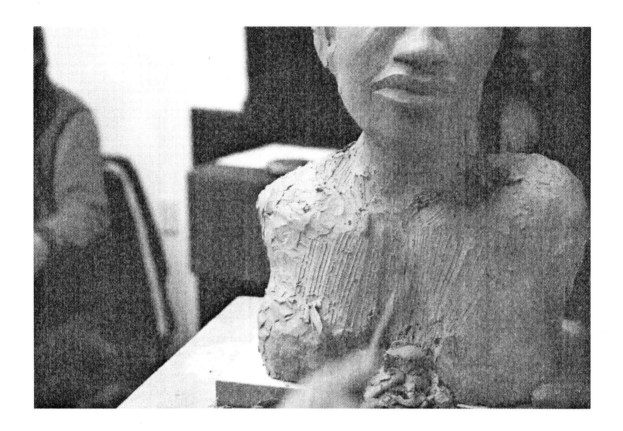

The sharper end and the more curved end of the wire at the other end of The Tool are used for different reasons. They provide different results. Convex (sharp) and convex (reducing or "take" brass).

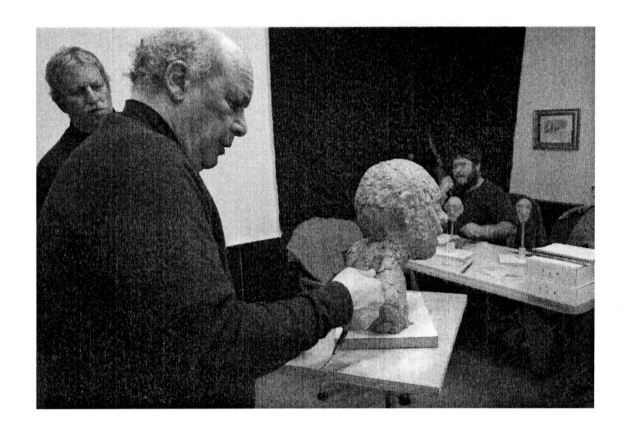

The inner curve will work for you in ways you cannot achieve with your hand.

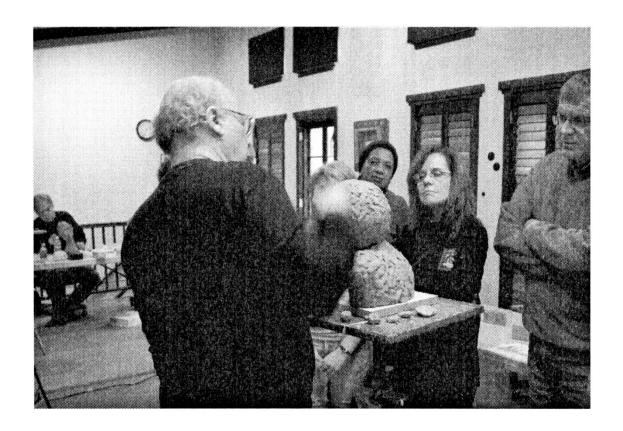

It is neither a butter knife nor palette knife. Do not spread or draw the clay around.

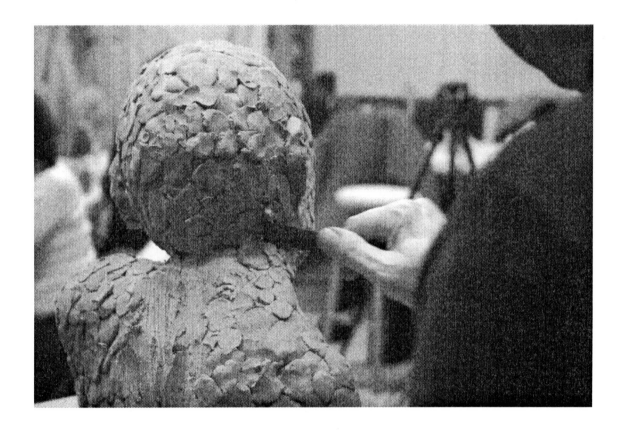

The Tool is the only thing that will be touching the sculpture. Use The Tool in place of the hand to achieve results in sculpting.

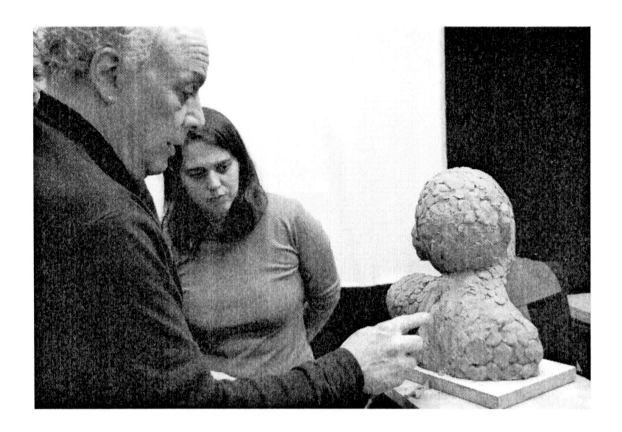

Don't smush with your fingers. Smushing, smearing and buttering are techniques strictly reserved for ceramics, drawing and painting. There you can smush all you like.

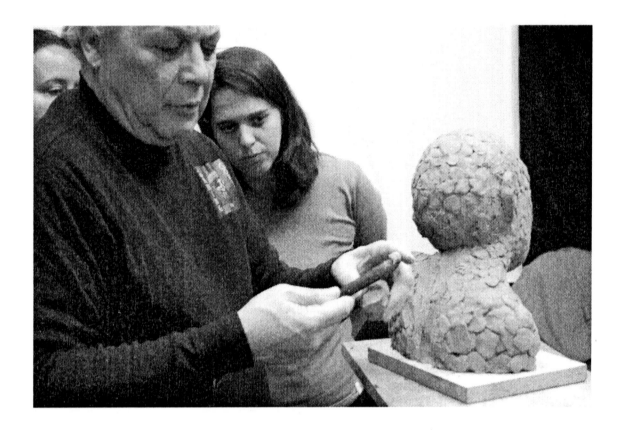

Remember that in this class you are not trying to make a great sculpture. You are simply trying to develop the habit of using The Tool. The sculptural forms will develop naturally as a result of good sculpting technique.

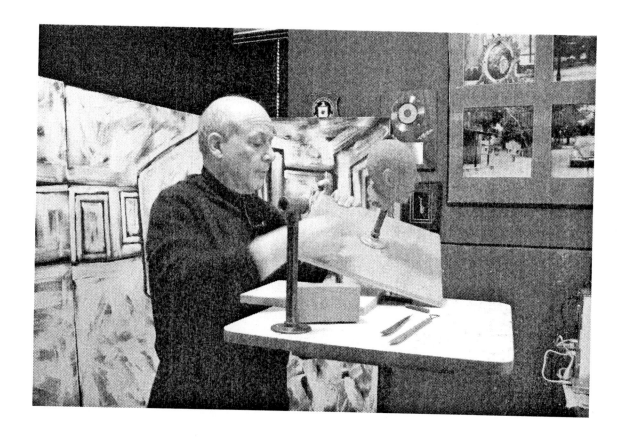

I'm not smoothing the clay; I'm just laying it in there and I'm lightly and gently attaching it. I'm using The Tool to attach this mass to the rest of the masses by the edges of the pellet. That's all I'm doing, I'm not pushing or flattening or smearing it on, all of which are marks of an amateur.

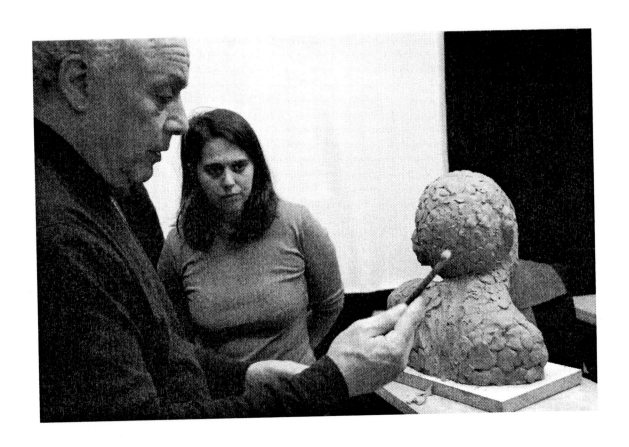

The Tool carries the clay to the form and tacks it on lightly, so it will stay there.

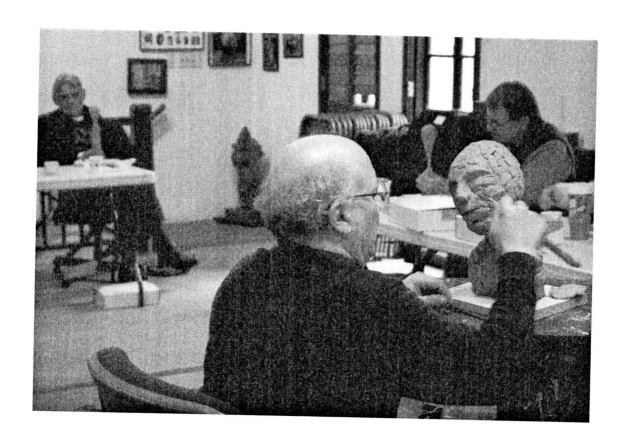

Everything you must do to produce a great piece of sculpture can be done with The Tool. Using fingers and thumbs to smear the clay will ruin the piece and obscure the real problems and mass issues.

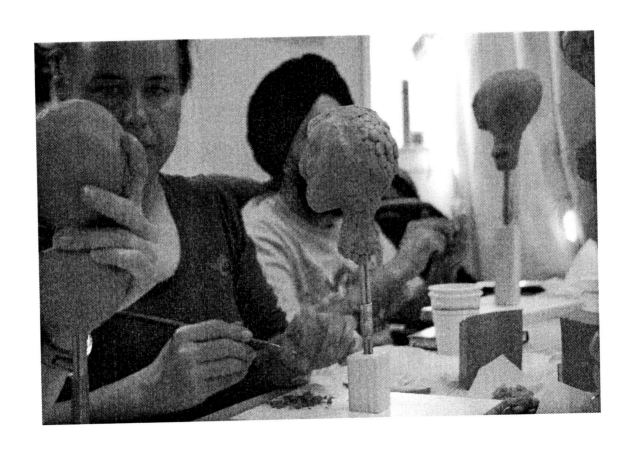

Learn how to use this tool as a drummer learns to use drum sticks.

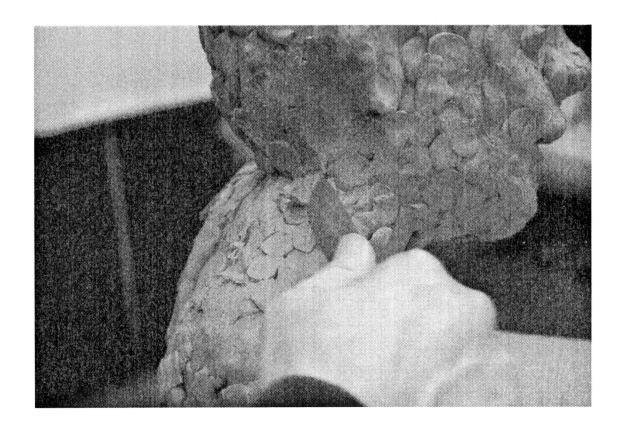

Your tool will perform the two basic actions in sculpture, "put" and "take", otherwise known as "additive" and "subractive". Those are the only two actions you are allowed in this course.

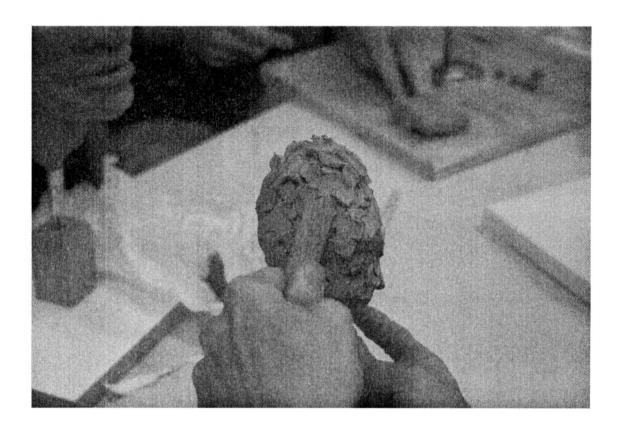

Stick softened clay on the tool and it will stay. Carry the clay to your armature, tack it on gently at the edges of the pellet, and slide the tool gently off by drawing it lengthwise toward the brass end.

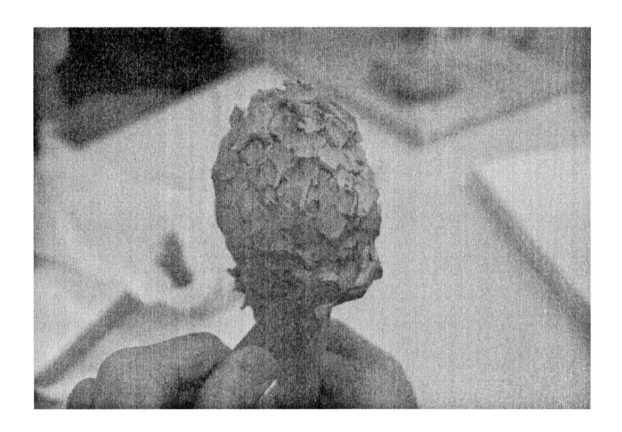

Action 1 is additive.

Adding a piece of clay to your main body of clay. That is called additive. Slide the tool gently off the clay so it will release. We build up the clay onto the armature slowly, small bits of clay at a time.

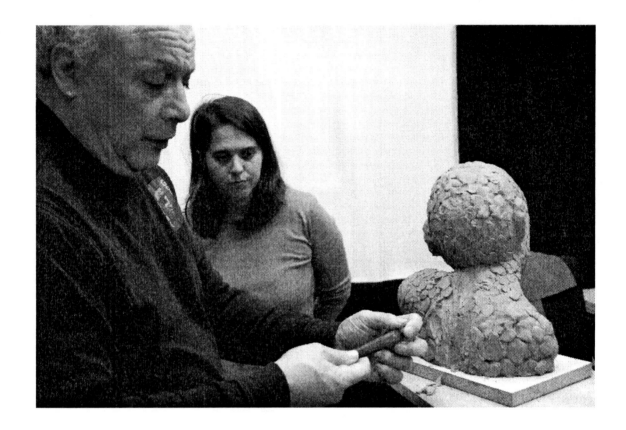

Press the blob onto the tool just enough so that it will stick lightly, long enough to get it onto the form. The clay will stick to the tool because it has oil in it. Carry the clay pellet to the main clay with the tool, resisting what every new student does, which is to smooth it on or flatten it by pressing down on it. Learn how to tack it on.

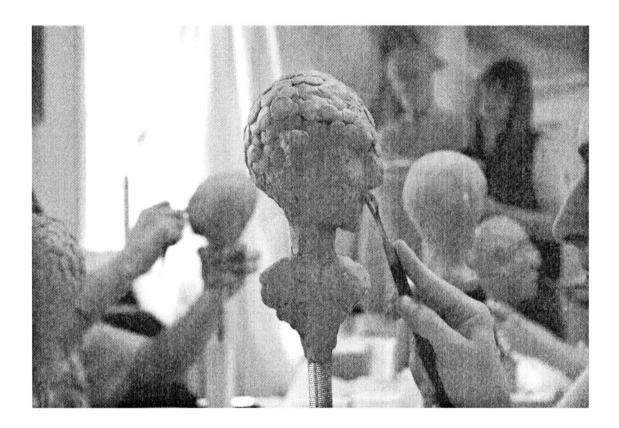

Action 2 is reductive.

The wire end is used for the reductive action. Reduce the sculpture by dragging the brass wire along the clay, gently — a little at a time. Don't throw away the small pieces that will result from the reductive action. They will be useful later on. You'll find that you can use a larger blob of clay to pick up the smaller shards because the soft clay sticks easily to other pieces of soft clay.

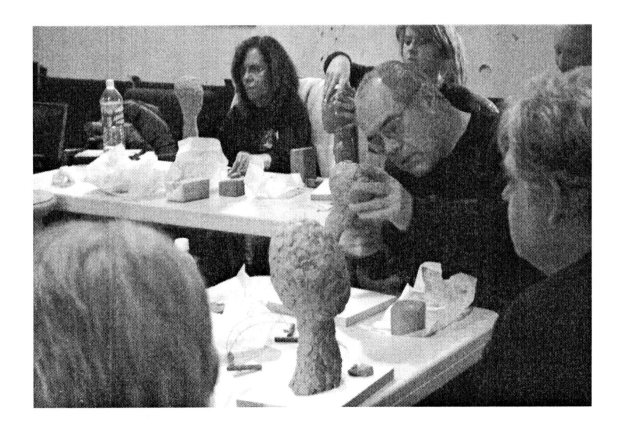

Don't make ears, eyes, nose, etc. at this point. This will make it one dimensional. You must turn the sculpture constantly, and work on developing and simplifying the form as a cluster of interpenetrating masses.

Work the sculpture always in the round. Keep turning it. Here we see California sculptor Neville Throckmorton turning the piece to see all sides as he works.

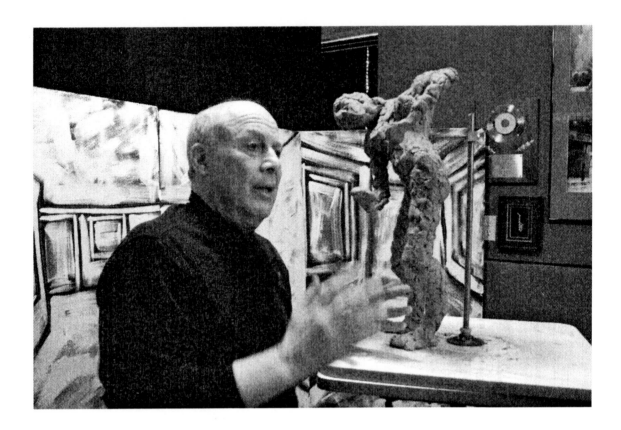

Working always "in the round" teaches you about mass so that, when drawing or painting, you will understand how to work on the picture plane as a whole thing and to keep it always asymmetrical, yet always in balance.

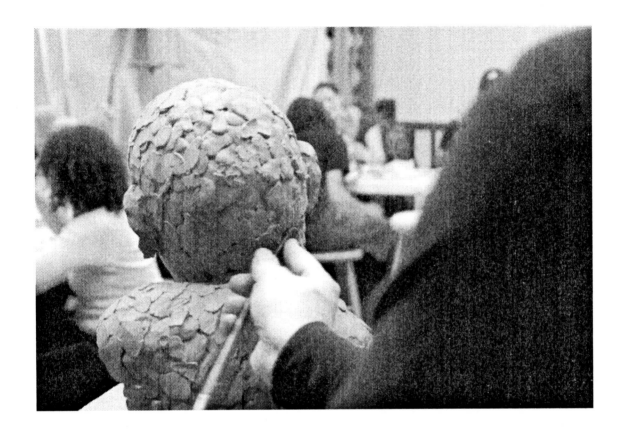

No undercuts unless you are definitely doing a bronze. You can have no undercuts in plaster or ceramic.

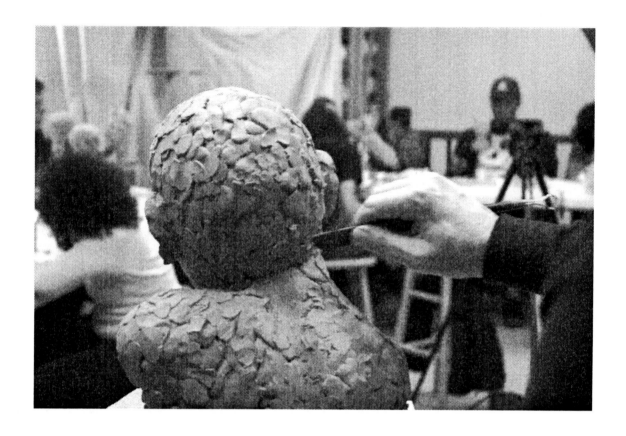

The issues are the same in all sculpture. You are constantly turning the piece, always, always working "in the round".

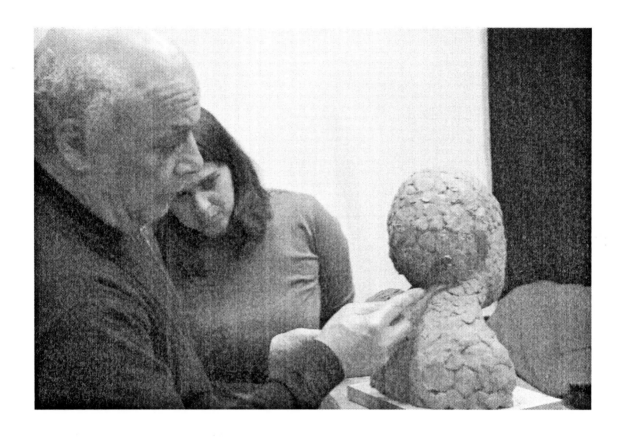

Sculpture as meditation is a very important idea. It is a tremendous stress buster.

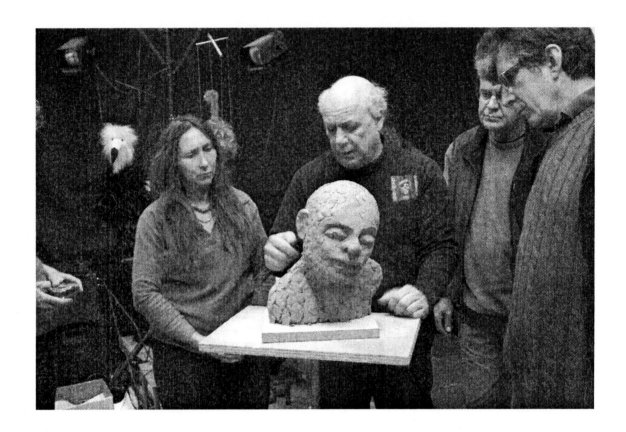

The face is composed of skin that is stretched over muscles. When you sculpt a face you will discover it is flatter than you imagine. To make it look right you must exaggerate. It will look strange to you at first. But to look right it must be exaggerated. The face is animated. It gives all kinds of clues as to what's happening. Renzo said that a still or dead face doesn't look right. Sculpture must be exaggerated, and caught in the middle of extreme animation or studied repose, or it will end up looking like a cadaver.

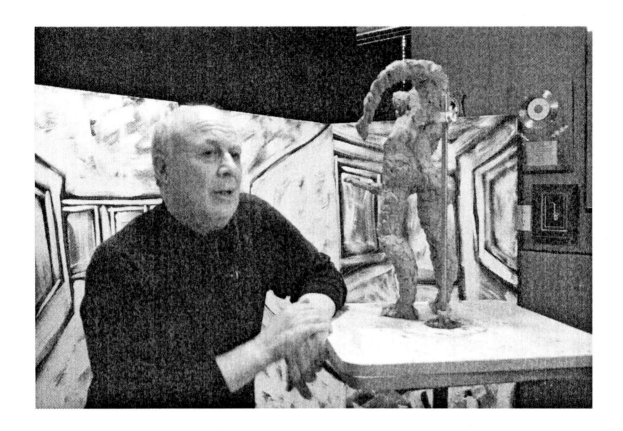

Underneath all of this is anatomy. Anatomy is important, but not completely vital. And you must work to develop a sense of design — not decoration but design — and of course a sense of self-worth but not ego. In other words, you really have to have a good sense of yourself as worthy of producing something of quality.

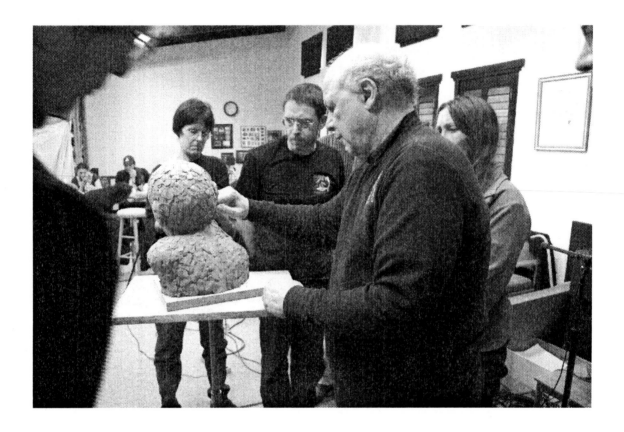

A good, strong foundation is what makes a good sculpture. Like a house, it needs a good foundation, and the best foundation is good observation. You cannot remember what you did not see.

Even though it is hard demanding work, sculpture should be fun.

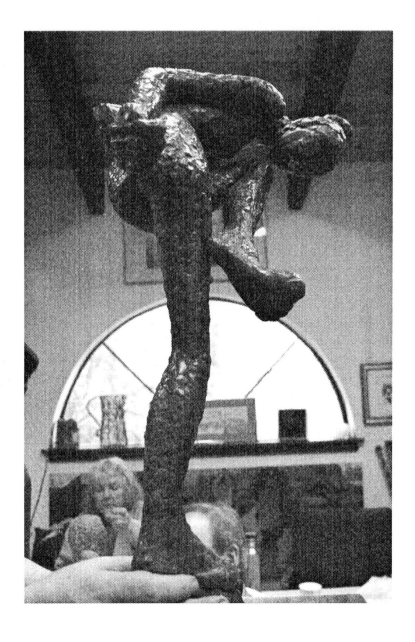

THE
DANCER

Learn about the body from sculpting, not from Gray's Anatomy.

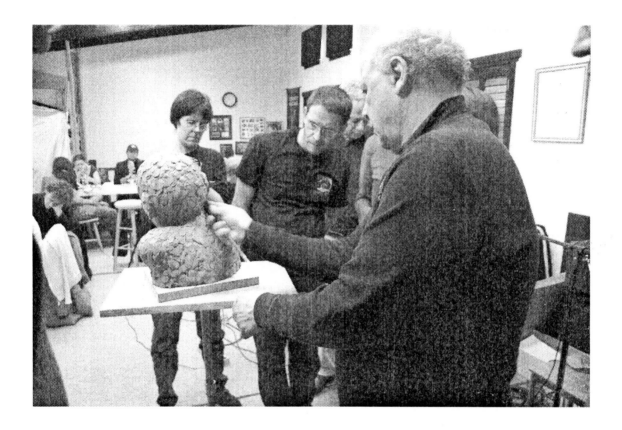

Resolving the issues with a sculpture can take a long time. Reveal the drama in the piece by not working the surface, but by simplifying the form, meaning to fill in the little dips and valleys and cut away the bumps and little localized hills, to establish the primary masses and form and eliminate "busy-ness" and undercuts.

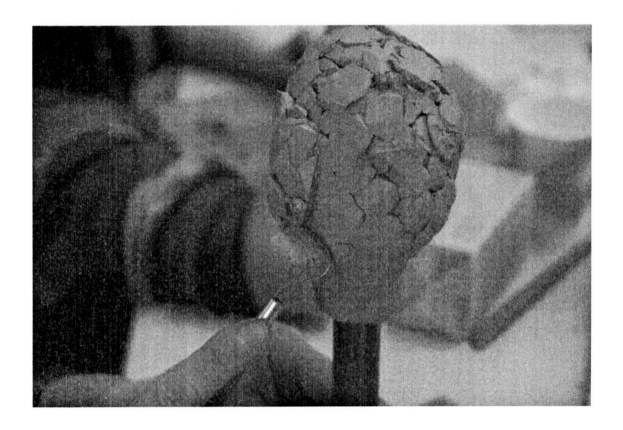

Established high points give you a general feel of the form, and lumpy areas which rise above the high points can be gently and slowly reduced with the wire end of your tool.

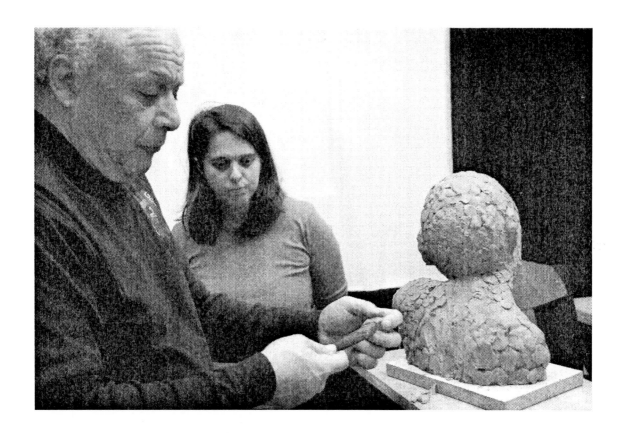

There are lumpies here. By the time I'm done with this I will have invested many, many hours into this piece to make it actually a finished, balanced piece. The finish work and resolution and simplification of masses is everything.

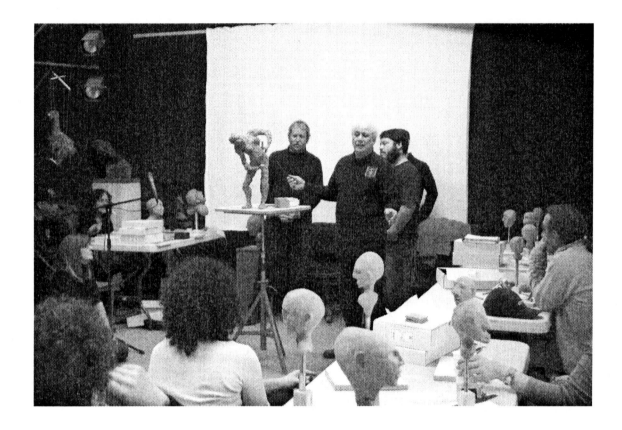

All the while you'll be working to simplify the form. Simplifying the form merely means taking out the little rough bumpy things so that it doesn't have cutesy wavy things — little valleys and hills — it's a clear piece. Also, I want you to notice that mass intersects with mass, which intersects with mass, and more mass. Each of these different masses has its own intrinsic shape and formation.

Think of a sculpture as a number of masses that are interpenetrating each other. If you think about it in terms of the outline it'll be a mess by the time you're done. Dips and rises are the things you're going to try to work out with your sculpture tool. Again I will work into this piece and I'll fill in most of the dips and valleys. We want a cluster of clearly defined and simplified interpenetrating masses that actually gives the piece a coherent quality.

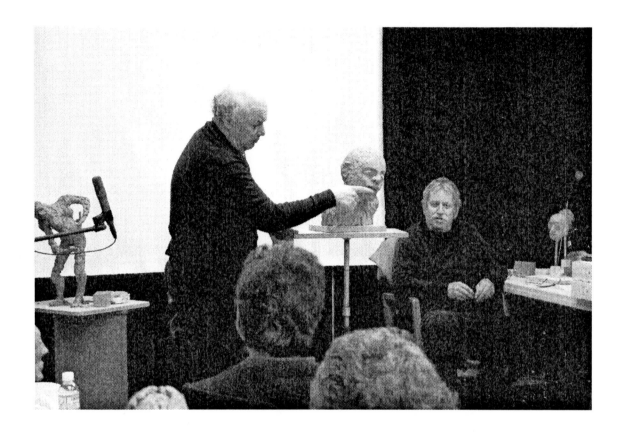

You need patience, to stick to it — hanging in is the most important thing here. I take a special vow when I start — not to abandon that piece until I have absolutely brought it to completion. No matter what, I'm going to complete that piece, even if I think it's going to be lousy. I've got a piece sitting on my desk right now that I'm going to complete before I go on and do other pieces even though I think it's going to be terrible by the time I'm done. It doesn't matter. I've got to be true to that piece. Once you start into a work of art, it's like a downhill ski run, a deep dive, or a mountain climb. You can't stop in the middle. You can't just say, "Okay, I quit." You've got to go all the way

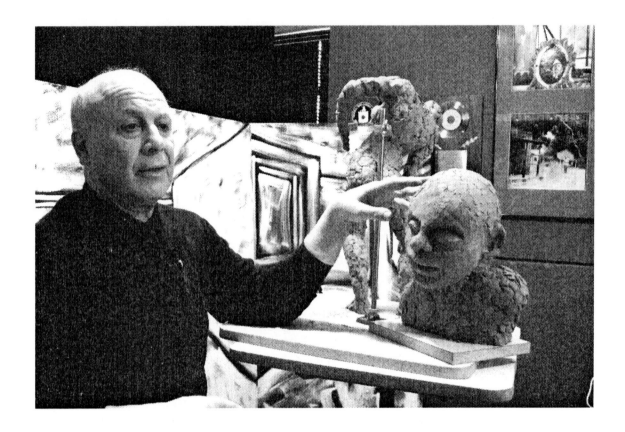

Exaggerate some things, cheat some areas to make it look alive. Exactitude is not truth.

Our first exercise at Otis was making an egg. A head is far easier, because mistakes hide amongst detail and misdirection. The egg is probably the hardest sculpture exercise, because there's no detail to hide behind.

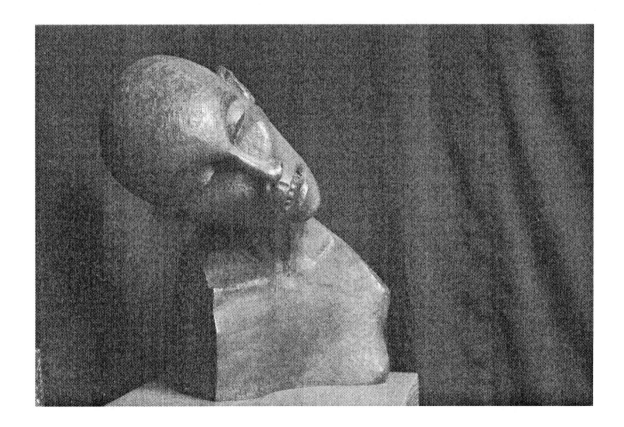

A completed bust weighs about 24 to 28 lbs in clay, and much more in bronze. It takes about 14 to 16 blocks of clay to make a small bust. This lifesize bust required far more, but this is the only clay you will ever need, so feel free to order a whole case at a time — it lasts for as long as the earth will last.

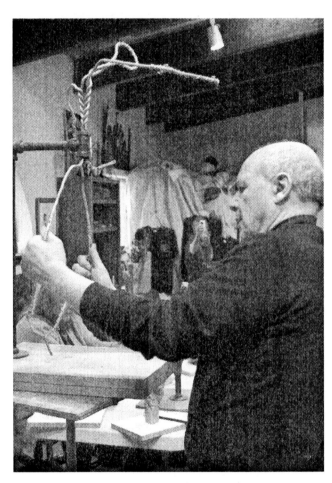

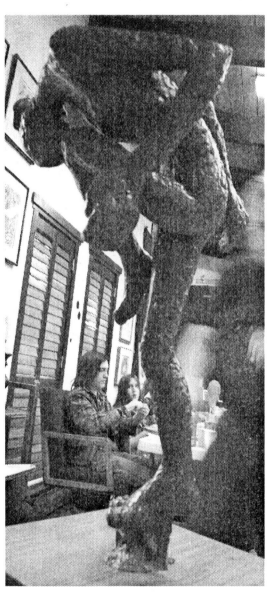

THE DANCER

For a figure like "The Dancer", you must shape the armature to the exact form you have in mind before ever loading the armature.

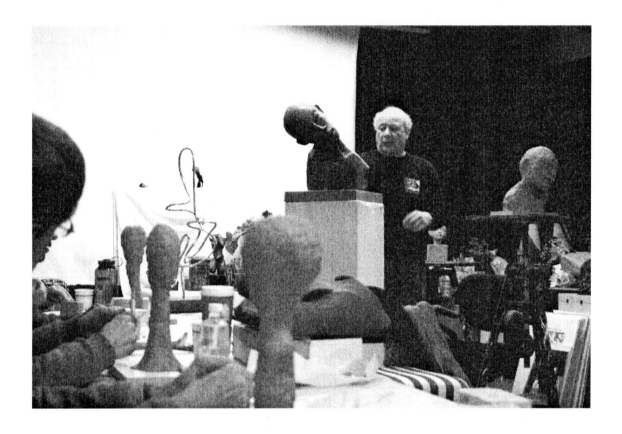

When you send your pieces into a foundry, the only ones you will get back intact will be head armatures. Figures and complex forms are cut apart to make separate molds.

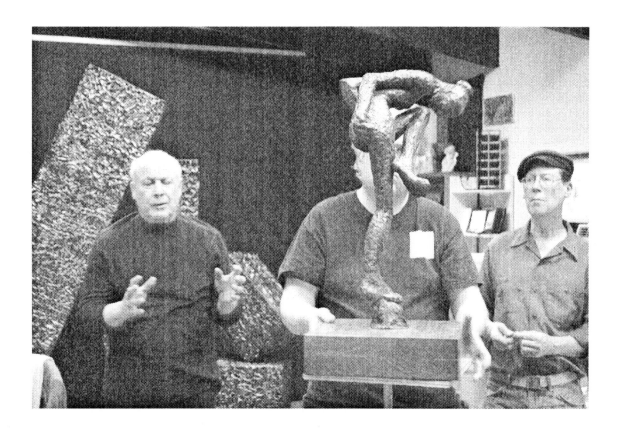

Figure armatures will come back in pieces because they have to be chopped apart and the separate castings must be welded back together.

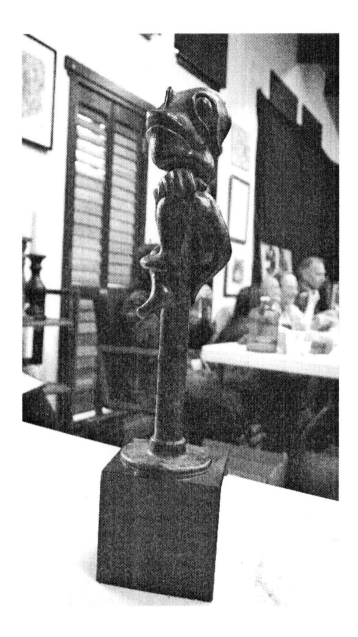

The Pole-Climber

There are a number of kinds of sculpture; stone sculpture, wood sculpture, clay of all kinds sculpture, glass sculpture, plexiglas sculpture, welded metal sculptures of various kinds, steel sculpture, nickel sculpture, bronze, of course, brass, and copper and wire and styrofoam and plaster, and Hydrocal. This Pole-Climber by Claude Needham was cast in solid bronze.

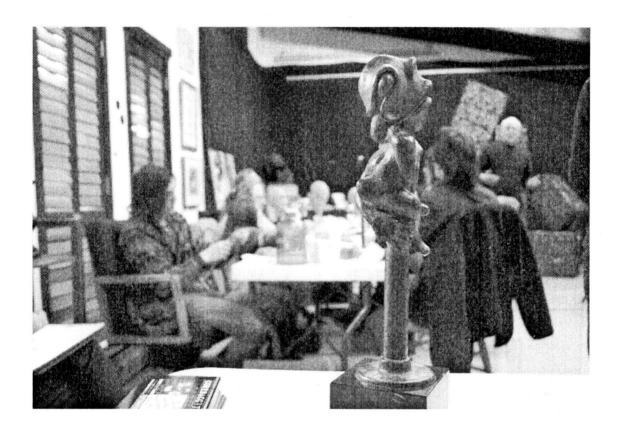

The kind of sculpture I'm going to teach you specifically in this beginner's workshop is the Italian style where you work a piece of clay with the intention of casting it up in some way, either as plaster, Hydrocal, bronze or ceramic.

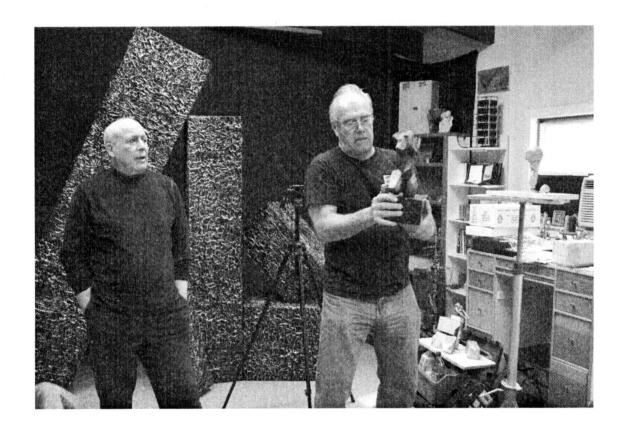

The castings can be several different types, and the molds for each type will be very different. We will explore the mold-making process in a little while. Behind us is a heroic 8-foot tall sculpture that is made by a different process but uses the same principles.

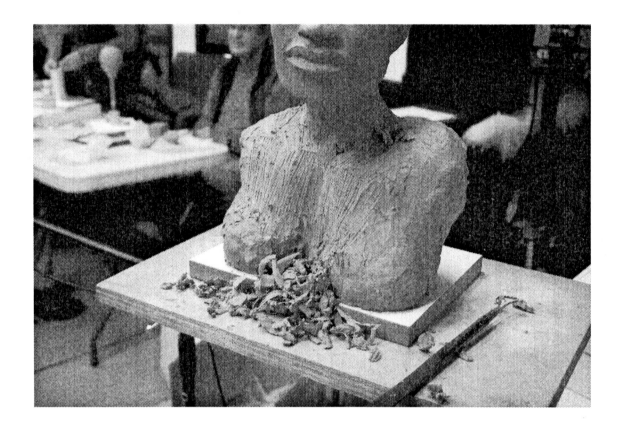

Most beginning sculptures are cast in what's called a "waste mold". More advanced work will be cast in a piece mold, and I'll explain the difference. A waste mold is built up around your piece and then you break the mold apart to pull the casting out. Your waste mold will never be used again. It's just the one time; you get one single casting out of it, which is fine because you can then finish it off as if it's bronze, put it up in a studio or in a gallery, and if somebody buys it, you send it into the Foundry, they make a mold from your Hydrocal — it works perfectly well. They'll have to make a piece mold from it because otherwise they'll destroy the original. Understanding the casting process is a major issue when planning and executing a sculpture, which we will address in a later chapter.

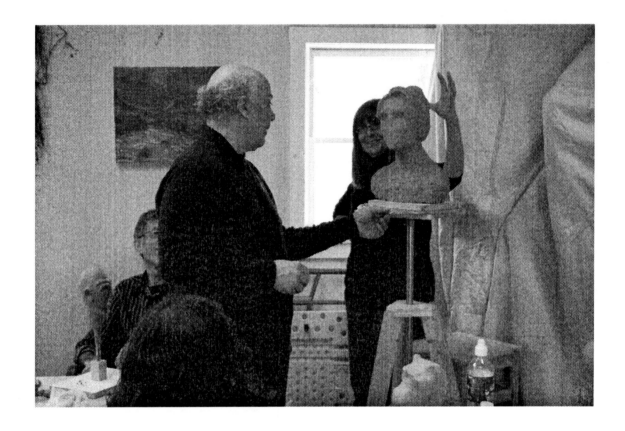

The piece mold is made out of several pieces which have been laid onto your master clay form in sections with little shaped cutouts in them called "keys", made by cutting out little sections of the mold, and then it fits back together. We will explore this in detail later on.

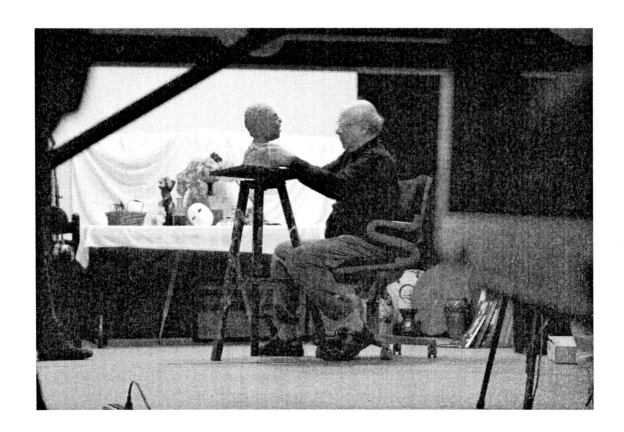

If you're thinking you're going to preserve your beautiful surface, forget it. You mustn't obsess over surface because it must be reworked later anyway.

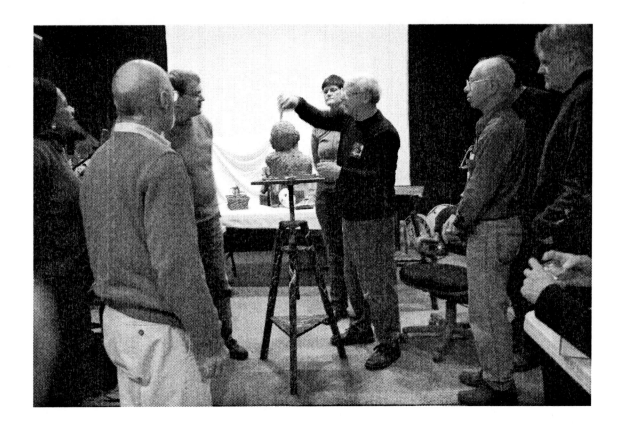

It's wondrous space age material that the foundry will use. They'll make a mold from your original and then they'll make a mother mold which goes around that, which is a stiff mold, a hard mold. Then they'll charge that up with wax up to about maybe a sixteenth of an inch, maybe an eighth of an inch, maybe three-sixteenths of an inch, depending upon the size of the piece. It'll be fairly thin. Then inside that they'll pour an investment core which is material that's impervious to burning or melting at very high temperatures. In the meantime they've sprued it with wax rods, and run gas channels and risers so that the expanding gases can escape past the sculptural body when the pour is made. Now they put this in a burnout oven and all the wax gets burned out. That's why it's called the "lost wax method". It's not that the method was lost, it's that the wax is lost.

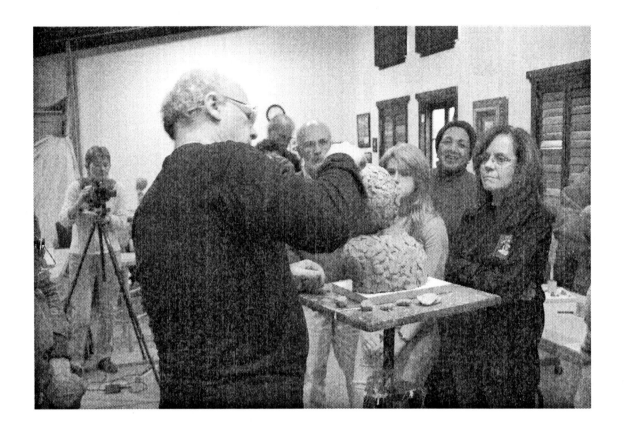

So then when the plaster-like investment mold comes out of the burn-out oven, it gets turned upside down, and then two hefty foundry workers with handling rods will lift up a cauldron of the hot metal that's been in a fiery furnace, in a crucible almost as hot as the surface of the sun. They're all gloved and masked up. I've actually done a couple of foundry pours. One crew takes the investment mold out of the burnout oven, lays it onto the pour area, and then the pouring crew will pour off the metal until the metal comes up through the risers. They want it to come all the way up, and all the gases expunged from the sculptural body, leaving no holes or spongy weak areas or gaps in the cast piece.

Now, they let that all cool down and, a couple of days later they'll break away the investment mold, and now there are all these sprues sticking out of the thing where the surplus molten metal squeezed out. We used to use a hack saw for those, but they now use little rotating power blades to "de-sprue", to cut those away from the piece, then they take a number of case-hardened 401 steel tools and they'll bang in the surface where the saw took off or altered the surface. That's called "chasing". It's the same as what you would do when you're making tooled leather. They'll chase the metal re-establishing the textures where those sprues had been. Then, they'll do a final cleanup to handle imperfections in the surface. Then, it gets bathed in various acids that produce what is called "patina".

You don't have to go to a foundry and get a pour and have the thing made in bronze. The actual foundry cost of a small bronze can be quite high. So when you think, you're not going to get more than $500 for a small bronze because people aren't willing to pay much for sculpture. They'll pay much more for wall art, which is a technical term for paintings, drawings and prints, but they will not pay a fair price for sculpture no matter how great, no matter whose it is. Even sculpture by very famous artists will go for a fraction of what they should go for, compared to wall art.

Typically, a sculptor gets only three times the foundry price. So that would be $600 to the artist, then the gallery marks it up double, some mark it up triple, but mostly double. So that would be $1200 for that little tiny bronze head. You can't ask people to pay that . . . they won't pay it. They simply won't pay it. They expect to buy a piece like that for $125. It cost the sculptor $200. They want to buy it for $125, $75 less than the sculptor paid cash out of pocket, and sculptors are not rich. But that's what happens. So you need a plan. Hang on — "The Plan" is coming soon

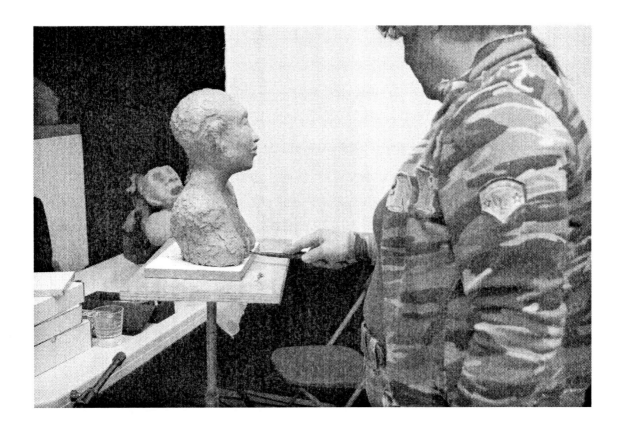

The larger pieces like Sculptor Sculpting the Sculpture . . . Here's a piece that cost a thousand dollars out of the foundry. So $3000 to the artist, $6000 to the gallery. Now there you can do it. That piece you can get $7500 for out of the gallery easily. So $6,000 would be very fair. As soon as you get up into serious size, you start getting some serious money, enough to cover your costs at least, and be able to make at least one more sculpture at a time. And that is typically what happens to the sculptor, they make one piece, then they sell it, then they make another one and they sell it. That's why sculptors typically make three pieces a year. Not too many pieces. It's also why we go to editions. I always do an edition of 22. I think that's a very good, fair edition size for both the artist and for the buyer. With an edition of 22 you eat up the foundry costs quite well because the initial foundry costs are very, very high. If you only produce one piece out of the foundry, you're going to pay for all your costs in one single piece. That is extremely expensive. That's all your make-ready, all the work that you do in the mold making. The mold making is the most expensive of all.

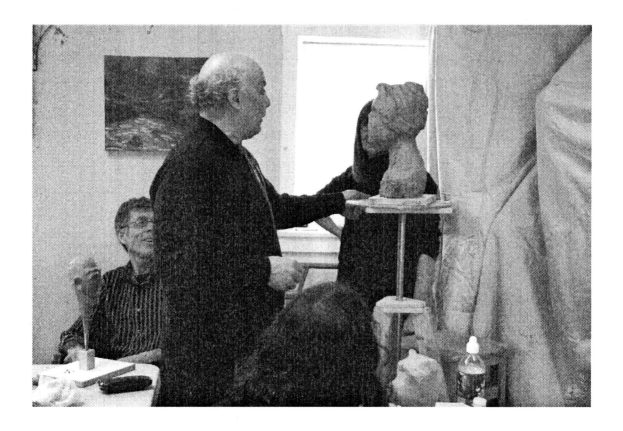

The life-size portrait is called a portrait head. That will cost approximately $1,200 to $1,500 to cast up, but it will cost about the same amount of money to make the mold. So figure $3,000 initial cost, out of pocket, for the sculptor. So $3,000 means that the sculptor has to charge three times that amount. Why? They have to charge three times the actual foundry price. So $1,200 is the foundry price and another $1,200 just for the make-ready, that's $2,400, then another $1,200. Why? Why does the sculptor need another $1,200? To live on? Not at all. A sculptor doesn't expect to live off their sculpture, not at all, not ever. You're not going to be making a living off sculpture; you have to make a living off your wall art. That extra $1,200 is so that the sculptor can make another piece that year. You figure to sell one, two or three pieces a year total, if all you produce is cast up in bronze. But there's a better answer that can actually make you money.

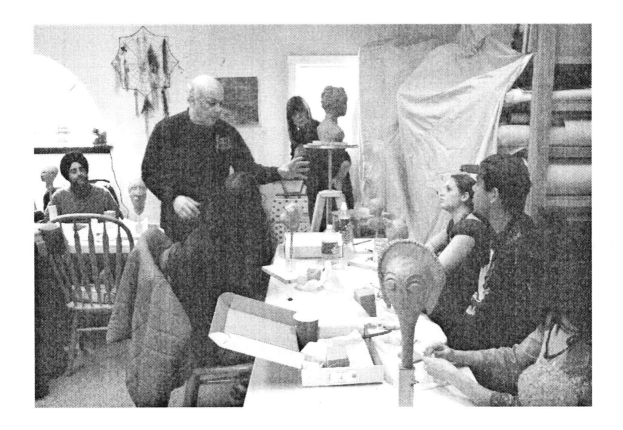

You have to charge the customer for three pieces — one for your customer, one for your gallery shows, and #1 for your own collection.

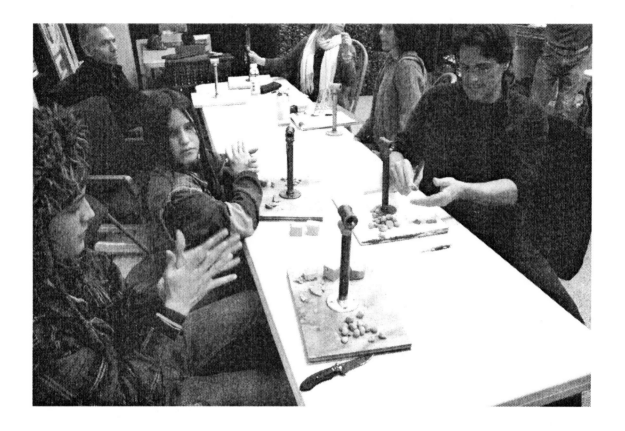

The gallery will sell from your number two piece. If the customer insists on taking the sample, they must pay an extra $1,200 because they're taking your sample away from the gallery, it robs you of the ability to sell it again until that sample comes back. Now how long does it take to get it out of the foundry? Anywhere from six weeks to six months to get a piece turned around in the gallery; sometimes a year, even a year-and-a-half. The Dancer took me two-and-a-half years to get back — two-and-a-half years, because it was cast in twelve pieces. Those twelve pieces had to be cast up separately, de-sprued, chased, welded, re-chased and then patinated. The Dancer is a very complex and expensive piece and it takes a long time to get something like that through the foundry process. Meanwhile, you've locked up all that ready cash.

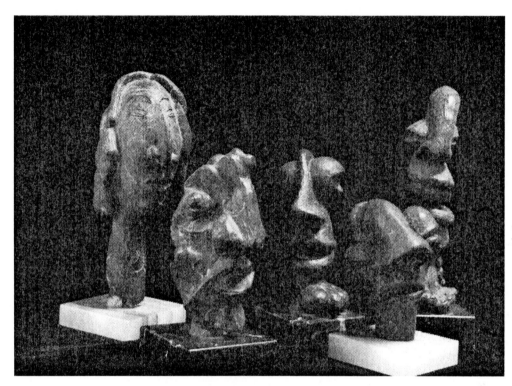

Small Bronze Heads

A selection of small bronzes on marble and onyx bases. They are between 5" and 9" tall. The two in the front row are by Tom X., on the left, and Claude Needham on the right, both of whom became professional sculptors after my master's class.

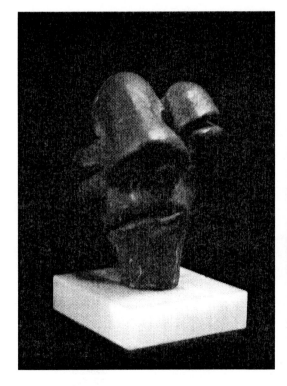

Little Alien Dude

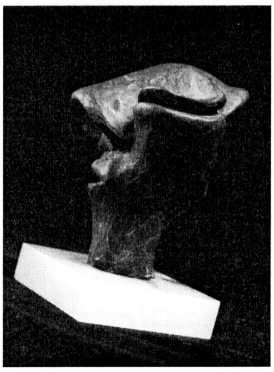

Claude Needham

Small bronze solid-cast head by Claude Needham from a flexible mold to correct for small undercuts.

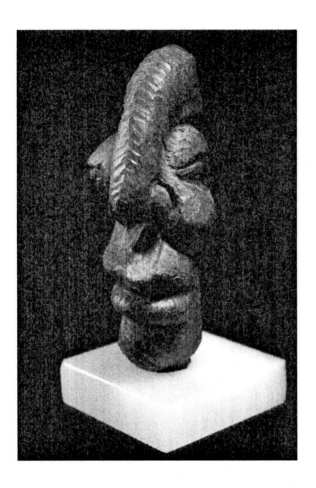

Cubist Head

Undercuts such as these in one of my cubist heads are typically not a problem for a really expert mold-maker, but can be a disaster in the hands of an incompetent foundry.

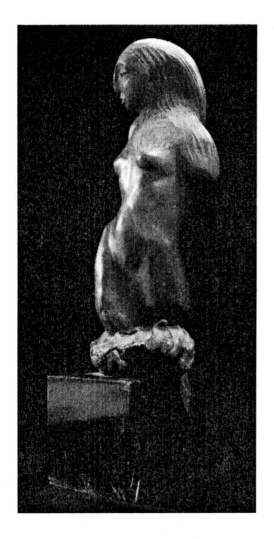

Mayan Lady

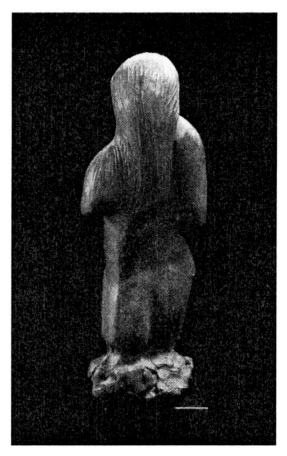

My 14" "Mayan Lady" which sold out at a gallery tag of $15,000 presented no undercut problems and was pure kindness to my mold-maker. She really appreciated the simplified form and the great opportunities it offered for some experimental patinations!

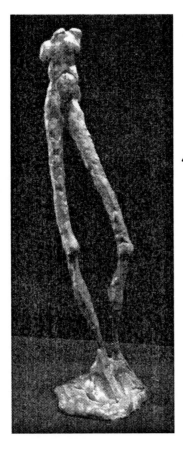

Lady Long Legs

"Lady Long Legs", sold out at $15,000 gallery tag, is a very large piece that had to be cast in four pieces, then de-sprued, trimmed, welded and acid patinated. It has its own self-standing bronze base and balances perfectly, as it should, without bracing.

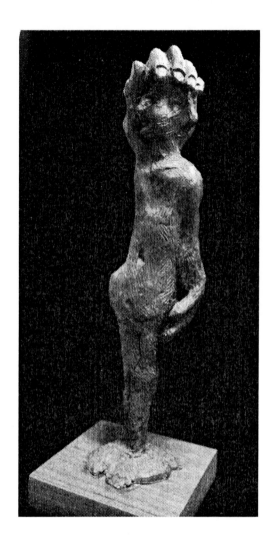

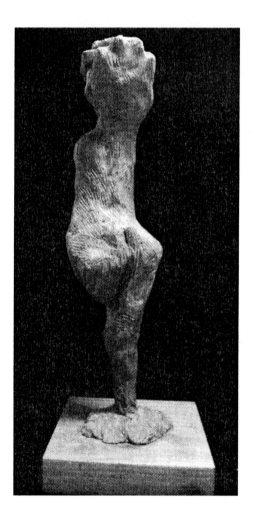

Sculpture Sculpting The Sculptor

"Sculpture Sculpting The Sculptor" is a sold-out edition of 22 18" bronzes that shows the need to sculpt "in the round" — it has interest from all angles, and can be displayed on an "open" stand in a walk-around area. The gallery tag was at $15,000, but the secondary market is much higher.

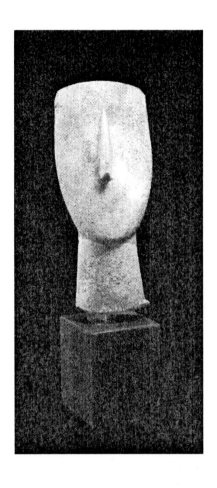

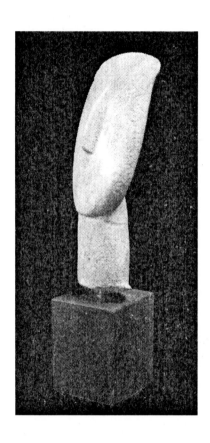

Cycladic
Head

Ancient Cycladic Greek heads were my inspiration for this ceramic piece. Knowing your art history can really help you to come up with ideas. Picasso based his first most famous cubist painting on African Masks.

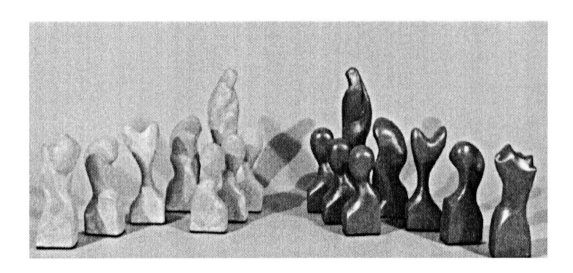

Ceramic Chess Set

We don't normally think of a chess set as sculpture but, of course, it is a form of miniature sculpture and follows the same general rules and problems for mold-making and visual stimulation. These were carved in wood, then molded for bronze and ceramic, and released in both forms for the market. Naturally the bronze set sells for far more than the ceramic, at $12,500 and $2,200 respectively.

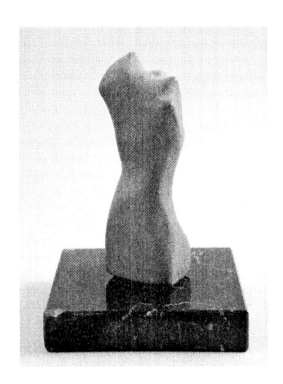

Ceramic Chess Piece

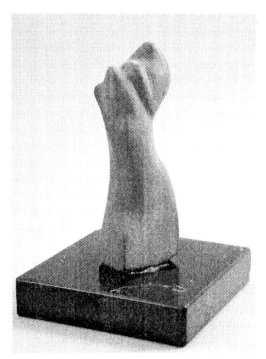

Here is a closeup of one of the chess pieces. Using your imagination, try to visualize this as a 24 inch tall piece, or even a monumental, and you'll see that the same rules do indeed apply whether the sculpture is small or large.

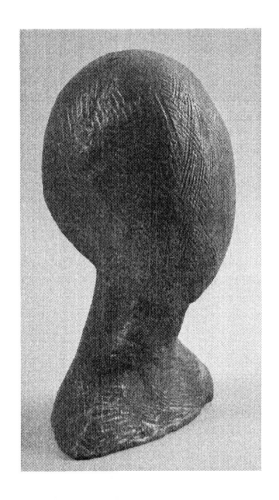

Head Without Features

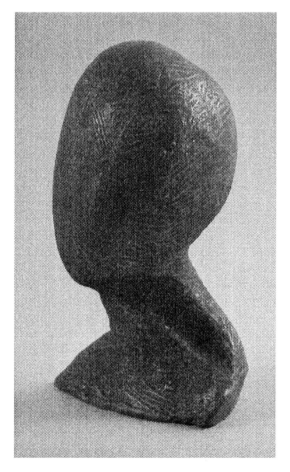

This piece, "Head Without Features", was created in Roma Plastilina, then made into a slip mold and cast up in slip, or liquid ceramic clay, then fired. In this case, it was low-fired in the ancient Korean pit-firing method called Raku Ware named after the family that perfected the technique. Raku is highly valued by Japanese collectors and is used with anything from tea ceremony items to tiny Ojime beads. The piece is approximately 6" tall and sold out at a gallery tag of $2,250.

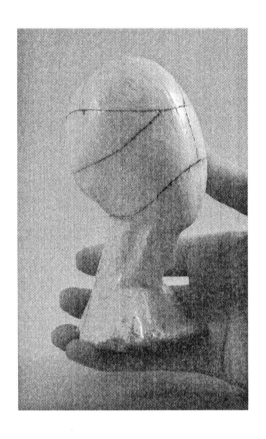

Head Without Features

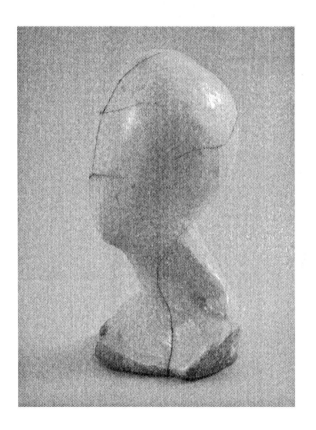

Crackle Glaze

Here is the same sculpture with a different treatment. It is also ceramic, but fired with a completely different crackle glaze that causes unpredictable splits along the surface, making each piece unique. The craquelure does not weaken the ceramic, but it is low-fire, comes through the pit as does the Raku Ware, and should not be an item of daily use.

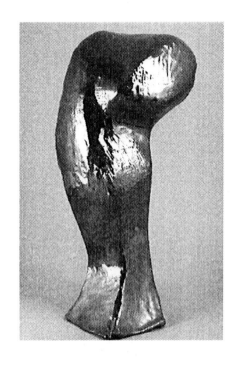

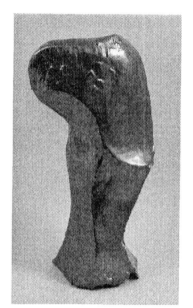

Figure In Space

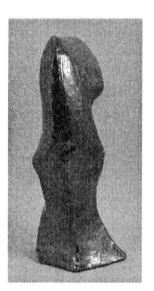

Here is an example of abstract form, "Figure in Space", made originally in Roma Plastilina, then molded as a ceramic piece for the market, making the price very reasonable for the average collector. The metallic glaze gives it an interesting and highly collectable look. The finished piece is about 11" tall and quickly sold out at a gallery price tag of $2,250.

Raku Ware #2

Here is a piece made in Roma Plastilina and cast in ceramic slip, then low-fired in a ground pit as Raku Ware — as a result, each piece that comes from the firing is unique and quite different from the others. It is about 6" tall and was cast up in an edition of 22 which sold out within hours of release, at a gallery price of $2,250.

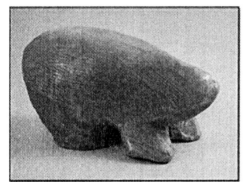
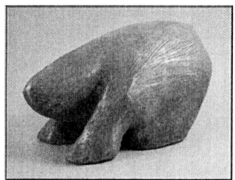

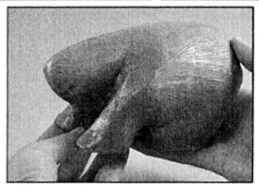

Raku Ware Bear

My little ceramic "Raku Ware Bear" was originally modeled in Roma Plastilina, then molded in a five-piece slipware mold and low-fired in a pit kiln. It measures about 9" in length, and the edition of 22 sold out at $3,500 each, within just a few days after being shown at a gallery opening at the Thunderbear Gallery in the Plaza at Santa Fe, New Mexico.

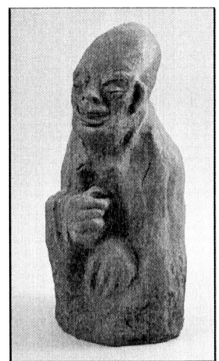
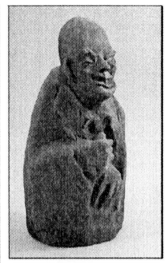
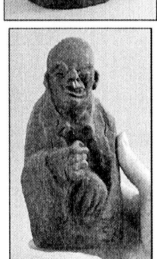

Zen Monk

This "Zen Monk" was also modeled in #2 grey-green Roma Plastilina using the same techniques shown earlier. It was molded in slip form and once again, fired as Raku Ware. The edition of 22 was sold out within days, at a gallery price of $4,500 at Thunderbear Gallery, Santa Fe, New Mexico in the early 1990s. The bronze version carried a hefty price tag at $12,500.

Cubist Style Head

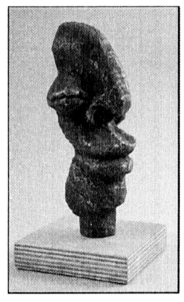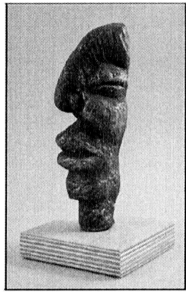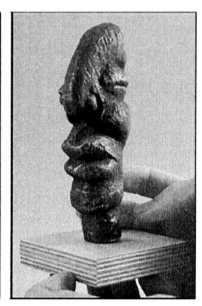

I modeled this small Cubist Style head in Roma Plastilina on a tiny 1/4" pipe armature. It was made specifically as a low-cost sculptural item for our local art auctions in Nevada City and Grass Valley, California in the 1980s, in an edition of 22 as usual. It has almost sold out, but has taken considerably longer to do so than the ceramic sculptures, at a gallery price of $6,000.

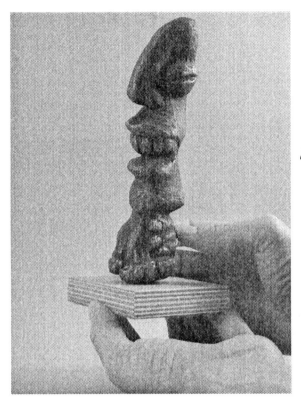

Bronze Head With Feet

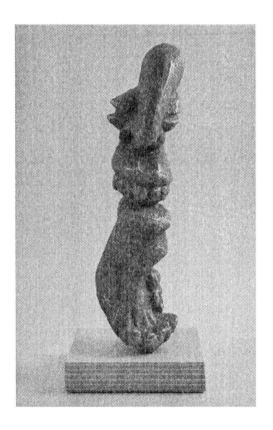

This Cubist "Bronze Head With Feet" was made in the same way at about the same time, and was modeled with the 403A sculpture tool in Roma Plastilina. Again, it has almost sold out at a gallery price of $6,000.

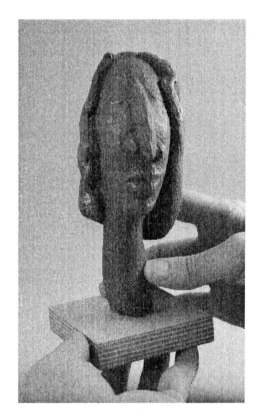

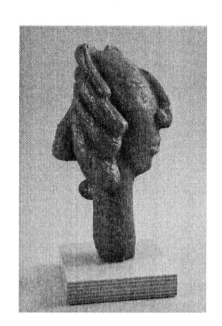

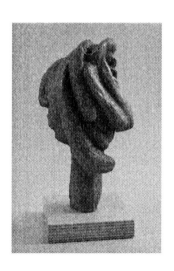

My "Modi Head" is about 8" tall and was made in exactly the same way, which is to say, it was modeled in Roma Plastilina #2 grey-green with the 403A sculpture tool and then cast in bronze in an edition of 22 at a gallery price of $7,000. It has almost sold out over a period of about ten years.

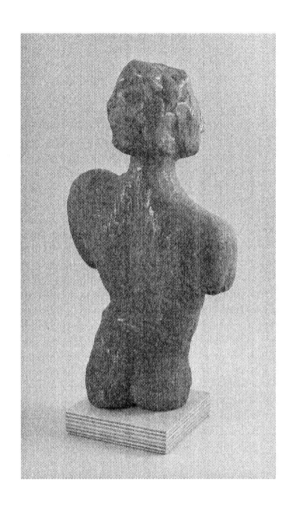

Medici Jester

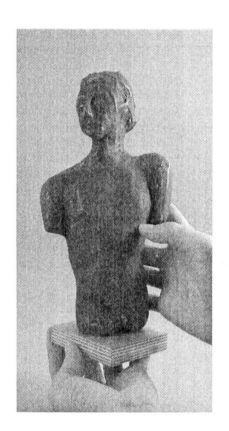

My "Medici Jester" is about 12" tall. It was sculpted in Roma Plastilina and was cast in bronze in an edition of 22 and a gallery price tag of $15,000, and is still "in print" meaning there are a very few remaining in the run — three or four.

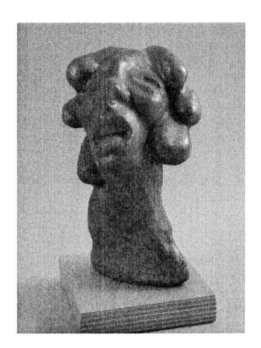

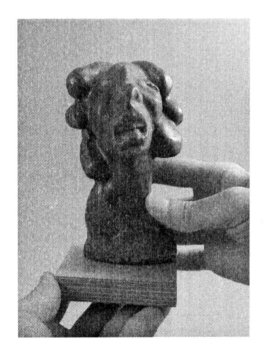

Medusa

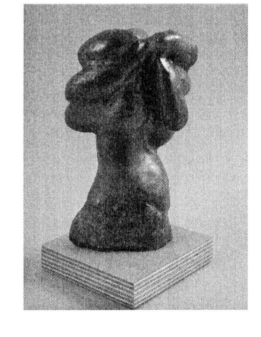

This "Medusa" was cast both in bronze and ceramic, and is a result of Roma Plastilina modeling with the 403A tool, and at $650 for the ceramic and $6,000 for the bronze, the ceramic sold out rapidly, and the bronze is still in print.

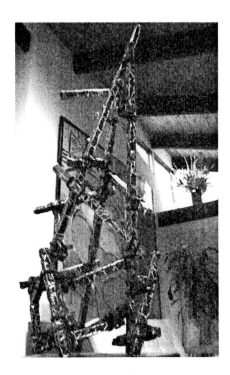

METAL

CLAD

This metal-clad architectural sculpture was made on commission for a Santa Cruz family in California in 2008. It is crafted of crumpled metal adhered to a hardwood frame, but follows the same rules of three-dimensional sculptural form in the round as all my other sculpture. It was commissioned at $12,500 at a height of 4 feet.

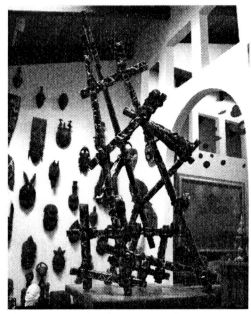

Metal Clad

Installed

This monumental 12 foot tall metal-clad wood sculpture was commissioned at $18,500 and went to a family in Northern California. The advantage of the metal-clad wood as opposed to bronze is that the floor does not need a mini-foundation built under it to hold up the very heavy bronze.

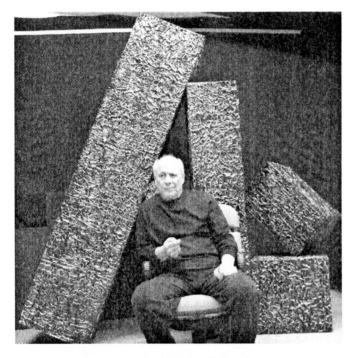

Metal Clad
Commission

This enormous metal-clad over wood was created for a $38,000 commission out of San Francisco, but the fee was split three ways, between the free agent, the gallery and the art company that hired me to produce it. The project absorbed my full attention and energy for a period of almost three months, and it is not something I would do very often. My actual out of pocket cost was close to $4,000 and my labor was intense and back-breaking.

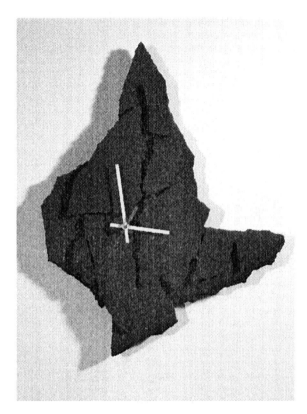

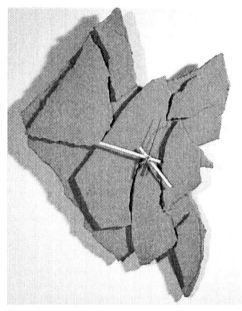

Sculptural Clocks

These sculptural clocks were crafted in styrofoam and then cast in bronze. They carry a gallery tag of $15,000 and are horrifically expensive and difficult to produce in bronze — each piece must be hollow-cast separately and then welded to the hollow-cast back brace, then the works must be fitted. Don't even think of doing this if you cannot find accurate clockworks for them.

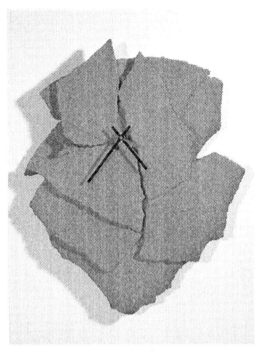

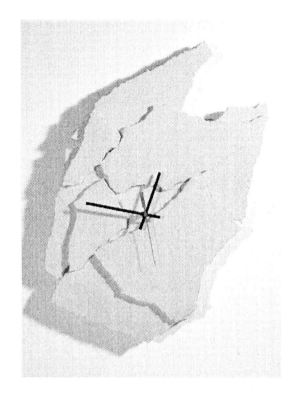

Styrofoam Clocks

Two more styrofoam clocks showing the original styro before bronze casting.

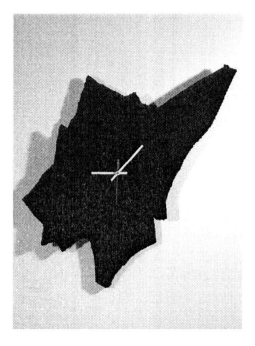

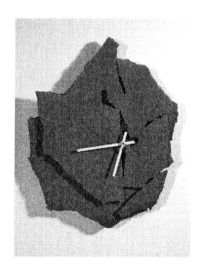

Ceramic Casting

Bronze Casting

One bronze casting, one ceramic casting of clocks. The ceramic casting was not successful in the sense that the clock parts were hard to fit and had to be modified considerably to go through the thick ceramic — the hole was miscalculated and the shank of the clockworks barely made it. The advantage is that the ceramic clock can be sold at a much lower price tag than the multiple welded bronze, and the weight comes out about the same, so the wall mounting must be braced with moly expansion screw mounts.

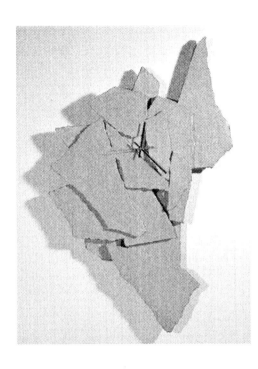

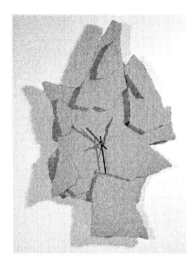

Styrofoam Clocks Before Casting

Two styrofoam clocks not yet cast. The straight styro clocks are far lighter and easier to mount, can be sold very inexpensively, but the catch is, nobody wants styro clocks — they'd prefer the higher gallery tag and the extra weight and mounting problems.

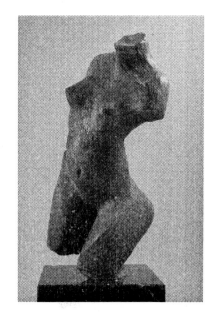

Striding Nude

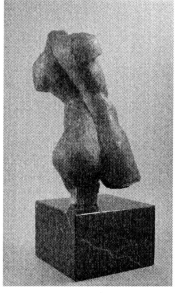

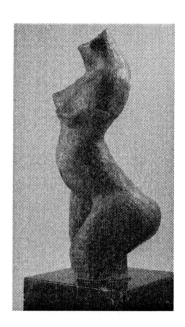

My popular "Striding Nude" is a bronze from Roma Plastilina and carries a gallery tag of $15,000. Keep in mind that when you see these prices they reflect over 50 years as a professional artist with a world-wide reputation and bonafide sales prices for paintings upward of $100,000. My 4x5 foot canvases were valued by Guernsey's Auction House in NYC at $50,000. My average 8"x10" canvas will often go for $1,200-$3,500, so the sculpture with its extremely high cost and profits often being split three and even four ways, is at rock-bottom bargain prices. I end up with very little if any profit from the bronzes.

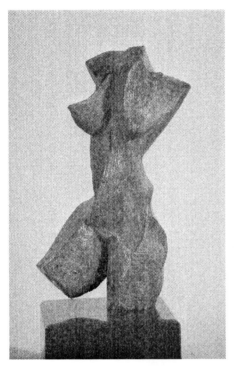
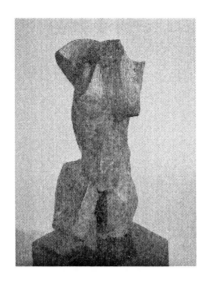

Cubist
Torso

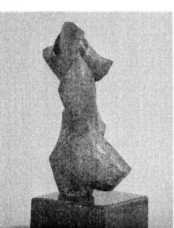
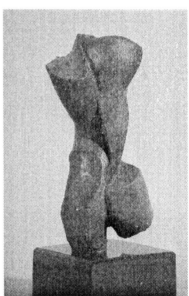

"Cubist Torso" was modeled originally in Roma Plastilina and like most of my smaller torsos is about 12" tall. It was cast in bronze with several different patinas, and has long ago sold out the entire edition of 22. They can now only be found on the secondary — auction — market, and very rarely does one show up. The gallery price tag when the edition was still available was $15,000 and now, who knows?????

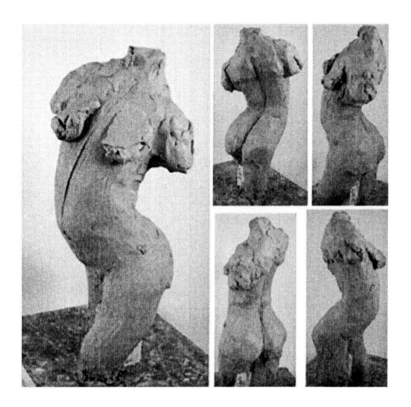

Nudess In Clay

Here is the Roma Plastilina buildup of "Nudess" as it looked on its first day. You can see clearly that there is yet a lot of work to be done here to "solve" the various "problems" of this piece. It went through stages of development over a period of days until it reached its final form and went to the foundry to be cast in bronze for the art gallery market.

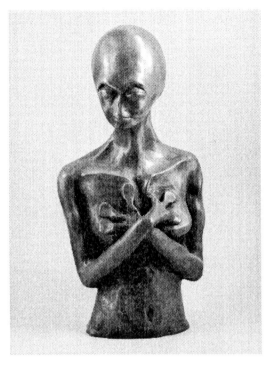

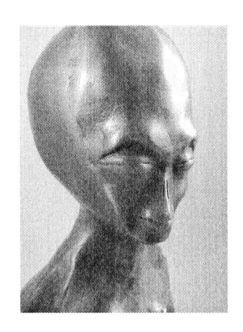

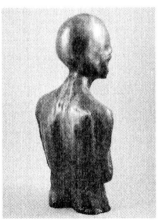

The
Alien

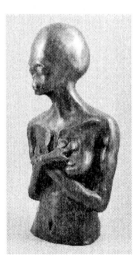

"The Alien", about 14" tall, was inspired by an actual Close Encounter which occurred many years ago and which still haunts me, so I crafted this up as a sort of "therapeutic stress-relief", and it worked fairly well. It grabbed people so strongly that the edition, at a gallery price of $15,000 sold out within a very short time after release to galleries in New York and California. On the secondary market, collectors are asking $22,000 and more for this piece.

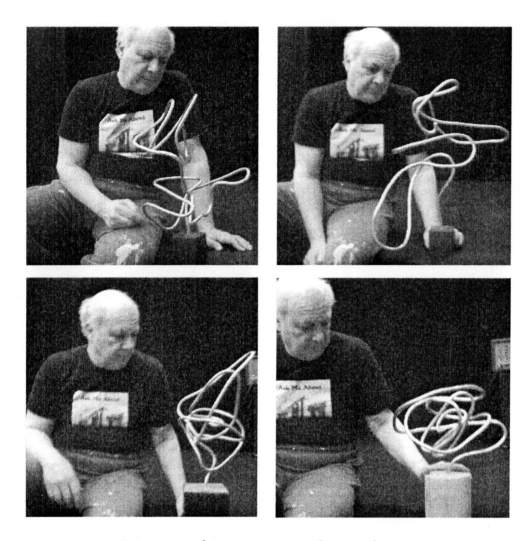

Heavy Aluminum Free-Form Sculpture

These Heavy Aluminum Free-Form Sculptures are very popular and are comparitively inexpensive at $1,250-$3,500 depending on complexity and size. They vary in height from 24" to about 36" and are mounted on rough-hewn wood bases typically, although some clients have requested and gotten onyx, marble and even welded steel.

Stone Abstract

19" "Stone Abstract" carved with point, chisel-head and tooth, then curved and finished with rasp and sandpaper, then waxed and polished and mounted on a wood base. Problem with stone is that it's one of a kind, not an edition, and the work in it is extensive, difficult and wearing, especially the finishing. Gallery price tag? Far, far less than a bronze in an edition of 22, sadly, so you won't find many stone sculptors out there.

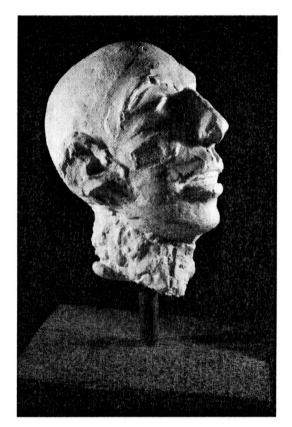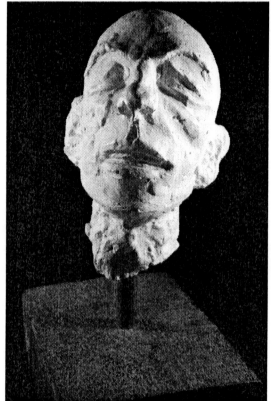

Life-Size Portrait Bust in Roma Plastilina

"Life-Size Portrait Bust" was modeled in Roma Plastilina, then a plaster "waste-mold" was made. After the Hydrocal pour, the waste-mold was broken away, revealing this piece, which was then finished with a rasp. Intended for the bronze foundry, this piece was never cast in metal — too expensive for the public, and it was a study made for my own experience in sculptural portraiture, not a paid commission.

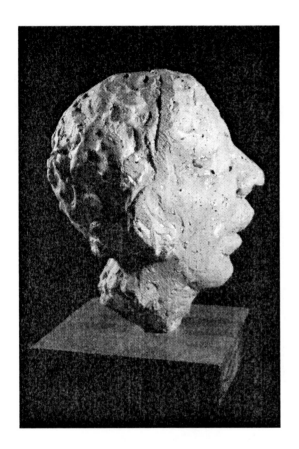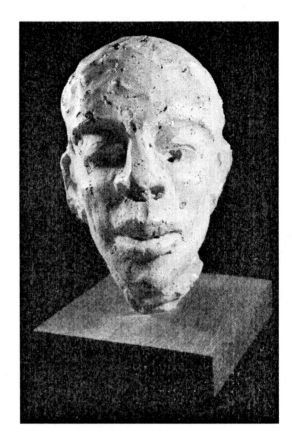

Life-Size Portrait Bust In Vatican Stone

Another Life-Size Portrait Bust, a study which was built up in Roma Plastilina with the 403A tool, then molded in plaster and cast up in Vatican Stone, which is Hydrocal with fine powdered stone mixed in. It's very strong and has the tone of Terra Cotta, making a very pleasing work. It's mounted on a hardwood base and resides in my studio. If completed in bronze, it would sell in the range of $35,000-$55,000 in a top New York gallery.

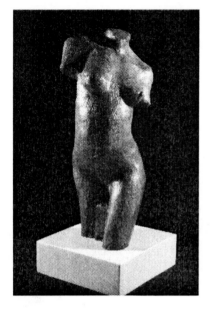
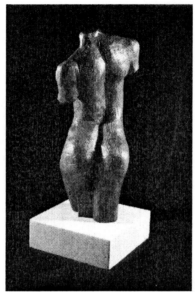
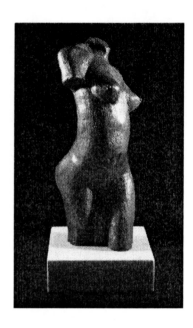

The Lost Nude

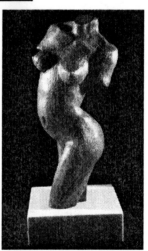

The "Lost Nude" is about 14" tall and was produced in the usual way, in Roma Plastilina on a simple pipe armature. You can see a section of the armature between the legs in the bronze casting. Note the twist of the torso here, to impart some drama to the piece. This is more the province of personal taste than a directive; I never impose my aesthetic on a student. I am interested in transmitting the skills and leaving the concept up to the artist. The piece was misplaced after only one copy sold, and has just now gone to market after three years from the foundry delivery. These things happen . . . an artist has to get used to it. The mounting by Dick Hart is made of beautiful Rippled Mexican Onyx.

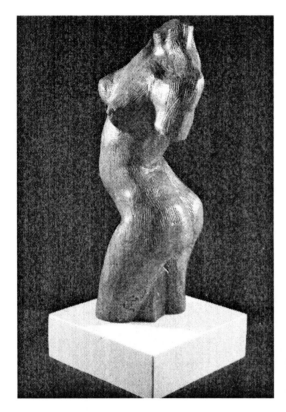

The Lost Nude

Working in the round, and only working in the round, produces a piece that looks good from any angle. The closeup on the right shows the signature and number which is inscribed on each wax pulled from the master mold, just before it is cast in bronze; I inscribe each one of the waxes personally of course, and hand-number them as well. Using a wax tool to inscribe your signature and the piece number is a vital part of learning how to sculpt. This one is numbered 1/22. There are never "proofs" of a sculpture.

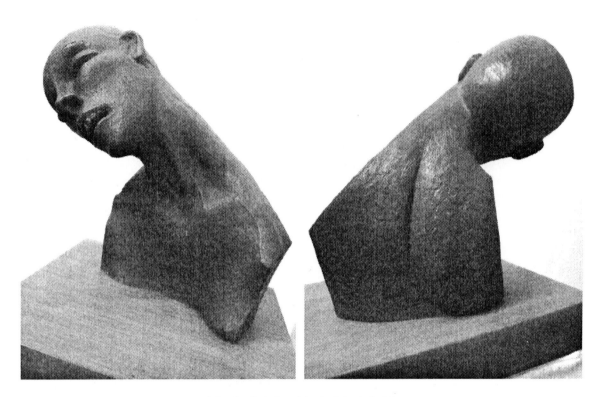

BLAU REITER

"Blau Reiter" is a massive "heroic" portrait bust, meaning larger than life-size, at a gallery tag of a whalloping $60,000 which mostly goes to the decorator, gallery and sales agent. Expensive to produce, and hard to sell!

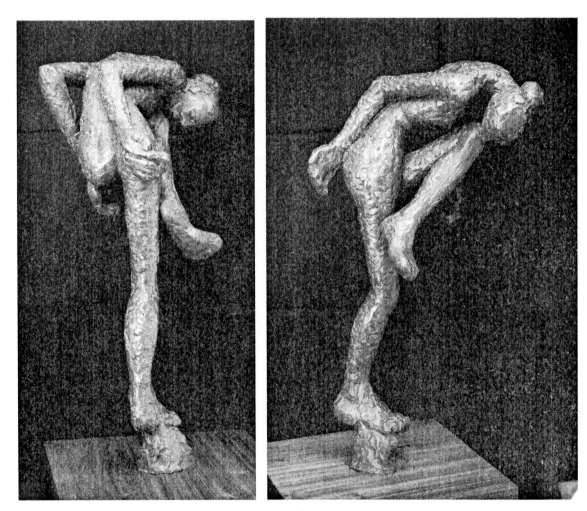

THE DANCER

Finally, let's look at a very ambitious project, my 36" "The Dancer", cast in bronze in only five pieces, it balances perfectly without a base and took the better part of a year to complete. A sellout at a gallery tag of $70,000, she can be found in several important collections and truly represents what I try to teach my sculpture students around the world.

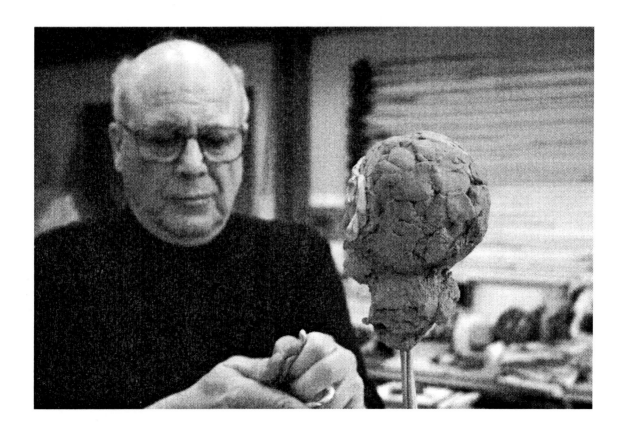

HOW TO MAKE A CHEAP CASTING FROM CLAY

Not everyone can afford to send their sculpture through the bronze casting process and, as a matter of fact, hardly anyone can these days, for several reasons, one of which is that it's very expensive and you have to charge quite a bit to the customer and the second is that most people today do not know what to do with a piece of three-dimensional art in their homes or businesses.

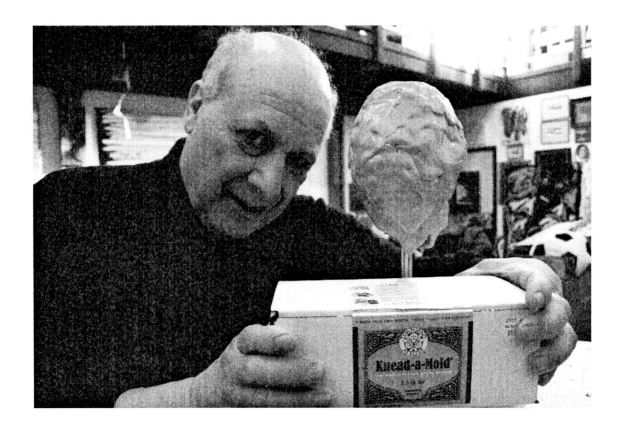

So the solution is to cast cheaply, and that's what I'm going to demonstrate to you now . . .

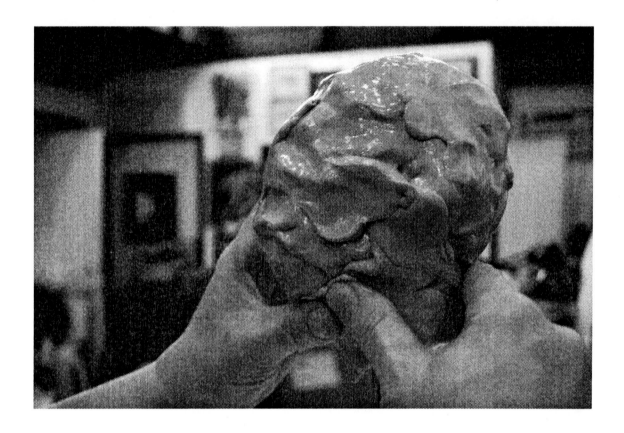

With a smaller piece of sculpture you might get away with a flexible mold. There are many types of flexible molds from latex and brush-ons to two-part kneaded non-toxic food-safe molds, all sorts of space-age products.

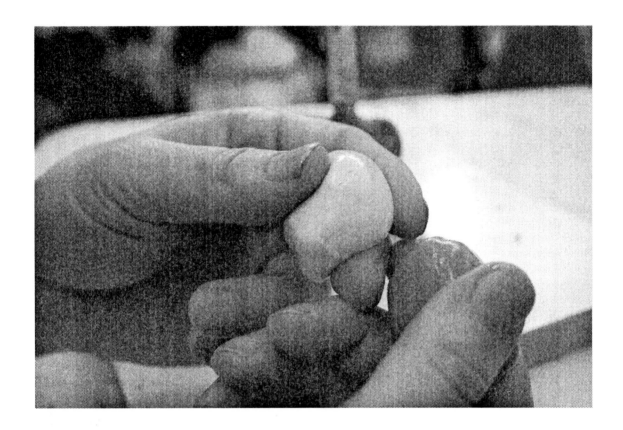

The kneaded mold is a two-part non-toxic epoxy that must be fully kneaded and mixed together to form a totally homogenous blue material. This is not the kind of material I would normally recommend for sculpture, but some folks like it for very small easy to remove from the mold type pieces, so it's worth mentioning.

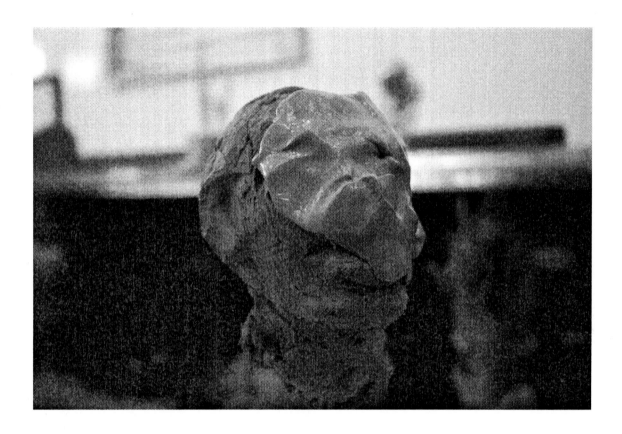

Apply the flex-mold gently and patiently, allowing it to seep into all crevices so that any detail you might want to capture is captured. If you're thinking of using the mold to create edible dishes, make sure the mold is food-safe and don't make the original out of something toxic.

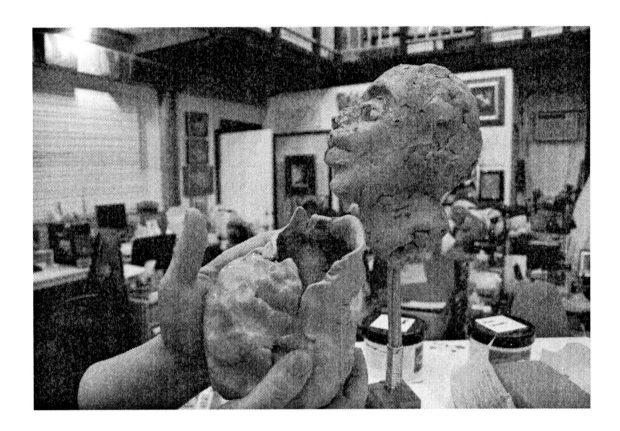

The main thing to remember about flexible molds is that they tend to sag and tweak, and might need a plaster "mother mold". The flex-mold might have to be cut somewhere to allow removal of the casting if they're fully dimensional, meaning not cookie, candy, butter or bread molds which tend to be more bas-relief than dimensional sculpture. I slice one side of the mold to allow easy removal of the piece, and then hold the cut parts together with large rubber bands when pouring the casting.

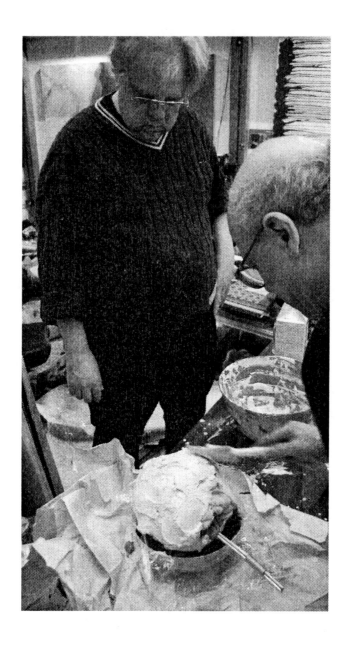

Enough about flex-molds — making an Otis style plaster mold is the preferred method — let's dig right into it now!

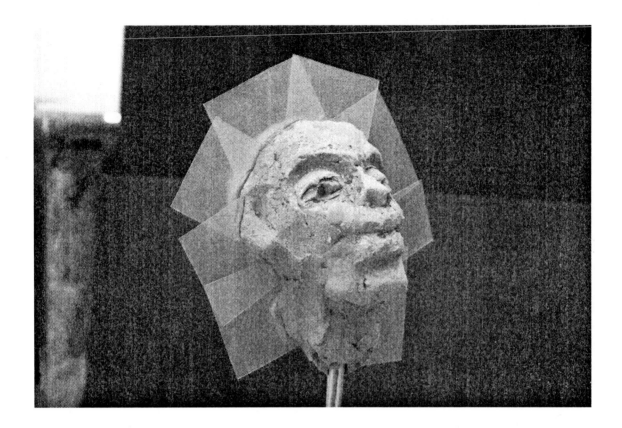

The first procedure is to install the plastic shimstock around the sculpture in a sort of halo. How you do this is very important and generally I like to teach the method over a period of several weeks or months. What you need to look out for specifically is a good solid "wedge" effect, where the rim of the halo carries an unbroken line around the piece.

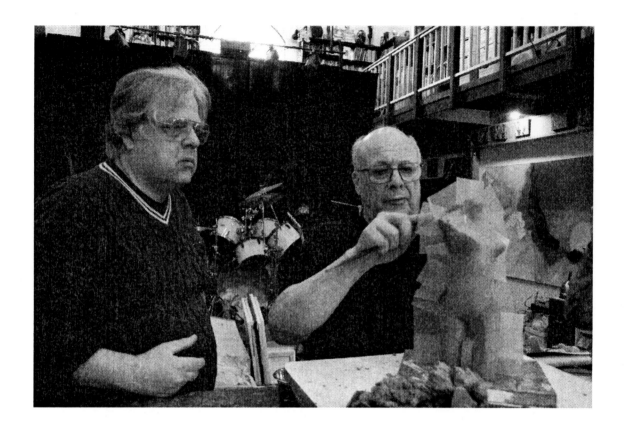

Secondly, you'll need, through long experience, to discover exactly how to calculate how the mold will come off the clay when you break the mold open. What that means to you is that the mold wants to come off the clay evenly and smoothly. Any "undercuts" will rip clay or mold away and that's not good. If clay will tear away during mold removal, so will corresponding parts of your casting.

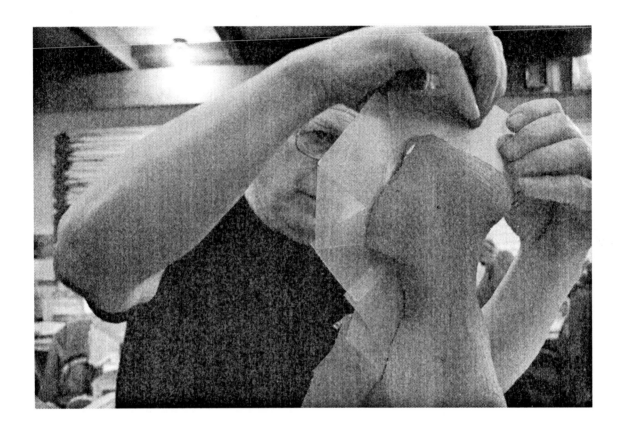

So we examine the piece to see how to shim it — what we're looking for is the fewest possible pieces of mold, hopefully only two pieces total. We are looking for the highest rim of the form, and following that around the piece. This takes some serious practice and a lot of failures before you'll actually figure out how it works.

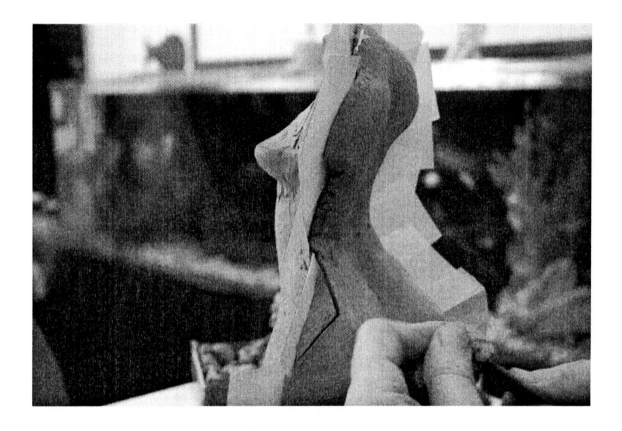

Then once we've established the high points and the rim of the shimstock line, we insert the shimstock around the sculpture in our halo formation, being careful to follow the rimline at the highest points.

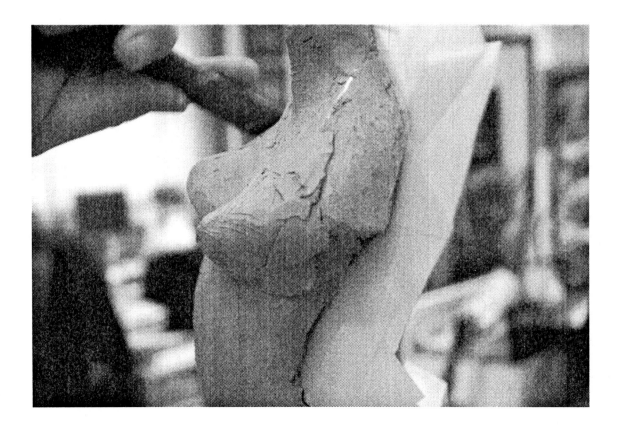

Now we re-examine the piece in light of the shimstock halo. Imagine cracking the mold open. By the way, cracking the mold is an expression meaning to separate the mold pieces; it does not imply that the mold actually shatters into little pieces. Imagine pulling the mold straight away from each side of the sculpture. Are there any areas that would pull against that? If so, we must "solve" those areas before proceeding to make the mold.

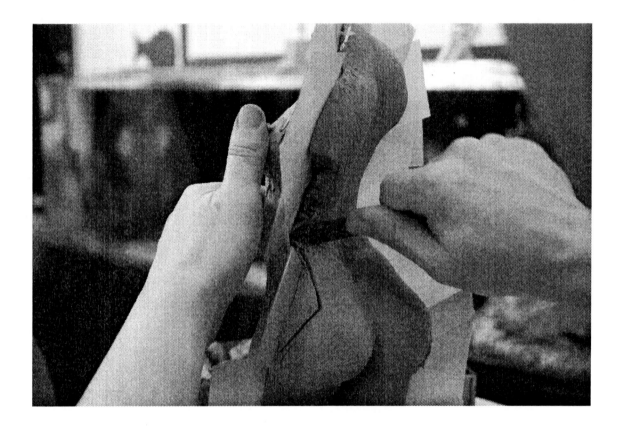

Each "hill" and "valley" that might drag against the mold when it is pulled away must be resolved, meaning that it must not catch when the mold is removed. That means to make the piece not resist the mold in the separation process. This is something I'd rather demonstrate in person, but that's not always possible, so I've posted a number of demonstration videos and made links to them on http://www.ejgold.com under "sculpture/molds".

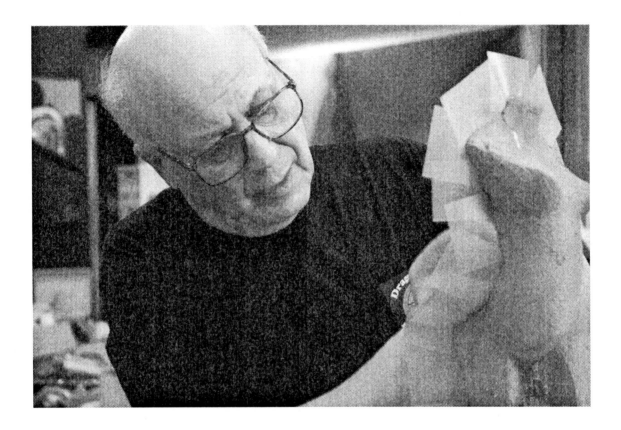

Now that we have resolved the sculpture, which might take a few additional days or even weeks to accomplish, we must re-examine the piece and determine whether or not the sculpture is still aesthetically to our liking, with all the changes to accommodate the mold-making and separation process. It will be necessary to make further changes in the sculpture to make it look good again.

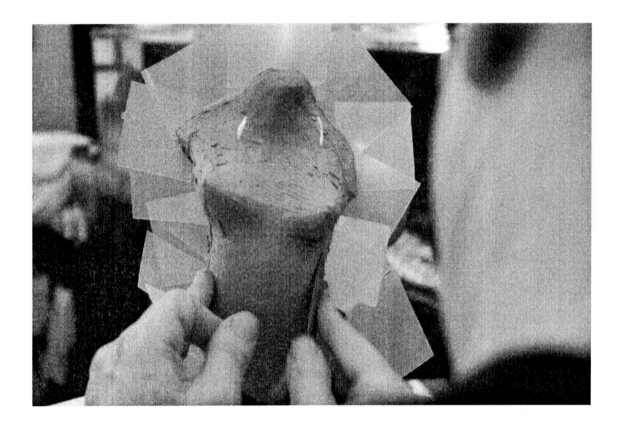

One of the things to watch out for in the "justification" process in which you re-establish the sculpture after having "rectified" it to not drag against the mold is that the edges will be slightly different. One advantage of the plastic shimstock is that you can easily see by placing a light behind the sculpture exactly where the opposite side of the sculpture will fall, and you can bring each side into compliance with the other. This is the process called "resolution".

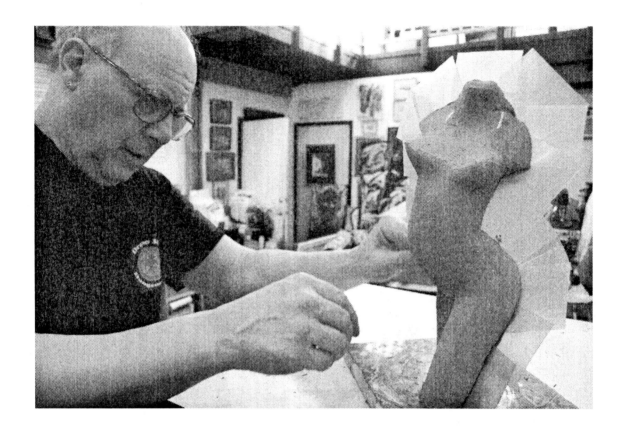

Now we are ready to begin the mold-making process using carefully mixed plaster of paris, but not just any plaster of paris. We want to find "Green Tag 20 Minute Set" plaster of paris. Do NOT use red tag, which is 10 Minute Set. It develops bubbles and is far too weak for a mold.

Using the "Island Method", we pour the plaster into the water until it forms a bunch of little islands. Don't forget to mix in six drops of fresh lemon juice to your water before adding the plaster. Measurements will vary with each sculpture and only long experience will give you the right answer each time about how much water and how much plaster of paris will be needed, but I have developed a little trick. I place a number of ready to pour molds around and use my excess to charge them up with plaster, making small pieces for sale using the extra plaster that always seems to happen at mold-making time.

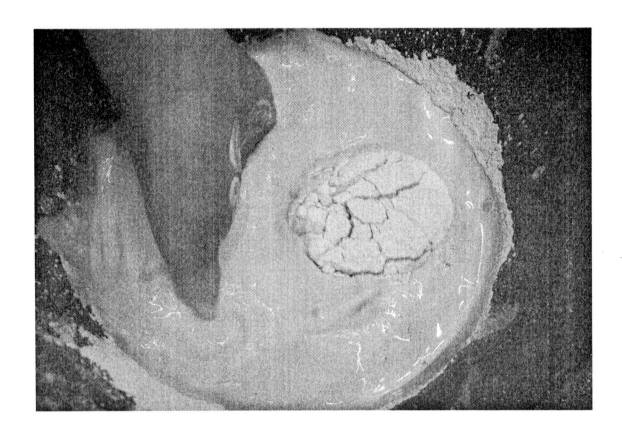

Watch carefully as you pour the plaster into the coolish, not to warm, not too cold, water you've poured into a not-too-large flexible plastic or rubber bowl. Make certain to pour it evenly all the way around, especially the edges. Don't just plop it into the center. You should use a large kitchen strainer to make certain that dried chunks don't get into the mix.

Dip your hand palm upward under the water, slipping it in under all the plaster, and GENTLY vibrate your hand to mix the plaster from underneath, allowing the bubbles to rise to the surface. You do not want any bubbles in the plaster. When it is thoroughly mixed, tap the side of the rubber bowl with a rubber mallet to drive any remaining bubbles to the top.

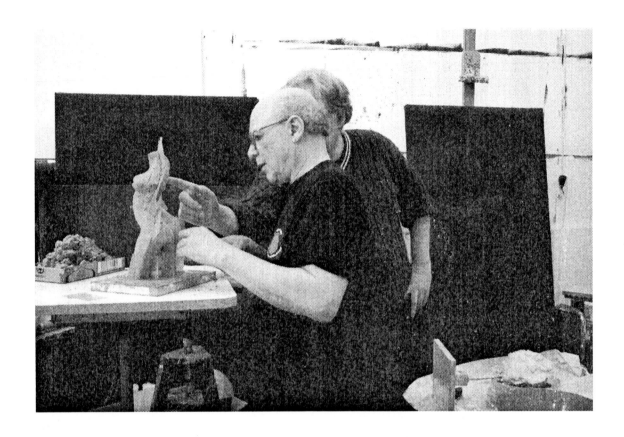

While you're waiting for the plaster to BEGIN to set — if it sets all the way or becomes too hard, you'll have to discard it and start with a new batch until you get it exactly right — you have an opportunity to grease up the sculpture with "mold release". I use ordinary Vaseline for the purpose. You have to use enough to get good separation, but not so much that it actually alters the surface of your sculpture. Practice, practice, practice gives you the best results. Only long experience can produce any serious mastery in this field.

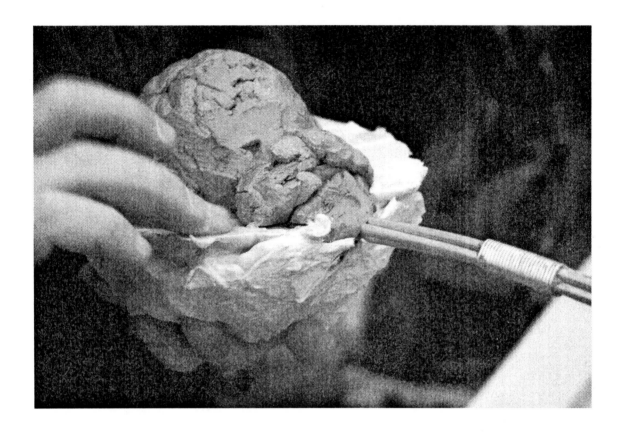

Okay, now we wait for the first side of the mold to "cure" somewhat. It will at first get very hot, then it will get very cool and damp. After about an hour or two, depending upon atmospheric conditions of altitude and humidity and ambient temperature, you'll want to turn the sculpture over onto the plaster mold side, exposing the clay which has not yet received the mold.

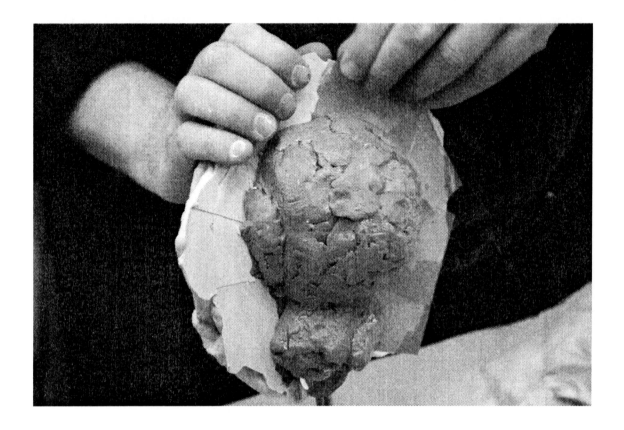

Remove the shimstock and use Vaseline to grease up the plaster where the shimstock was. Grease up any areas of clay that seem to need it so the mold can be removed easily when it's fully cured.

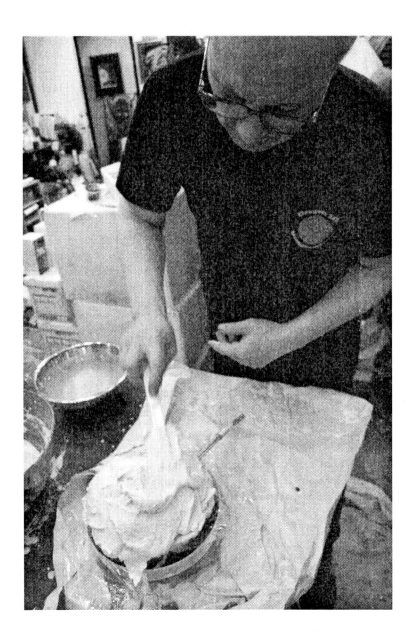

Now mix up your plaster, apply it as you did the other side, making certain to build up weak areas and to avoid leaving thin spots that might easily split when you crack, or separate, the mold.

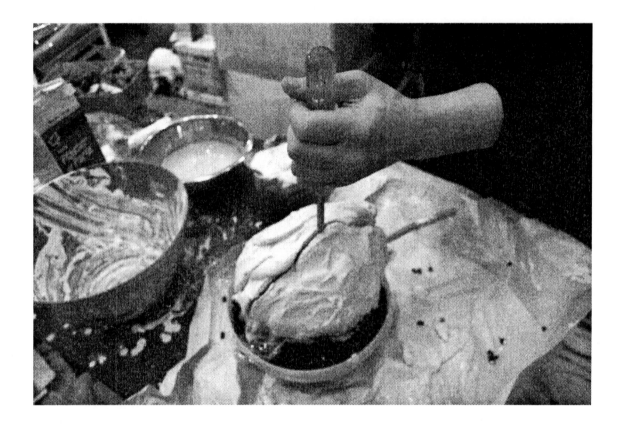

The next step requires some patience. Wait until the mold is ready for separation before attempting this. That might mean anywhere from ten hours up to a day or two, depending on atmospheric conditions. When it's ready, meaning as cured as it needs to be to retain strength but not so hard as to defy removal, carefully tap a wide flathead screwdriver or a chisel into the crack between the two sides of the mold, which is to say, where the shimstock was. Be very conservative with your tapping, gently, gently coaxing the two parts into separate sections.

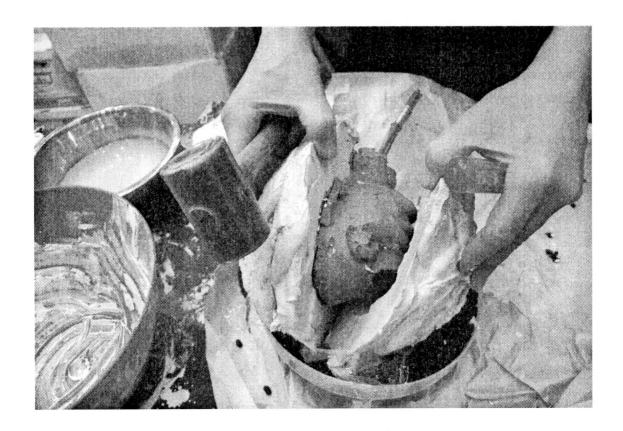

Now gently and carefully remove the clay from the mold. Allow the two or more pieces of your sculpture mold to sit with the side up that will be the casting. Wait until the plaster is totally, completely, fully cured. Again, that will vary depending on where you live and what atmospheric conditions are occurring at the moment. Very humid, wait longer. Very dry, not so long. Experience at mold-making and casting will give you the right answer after about fifty pieces, maybe more, maybe less.

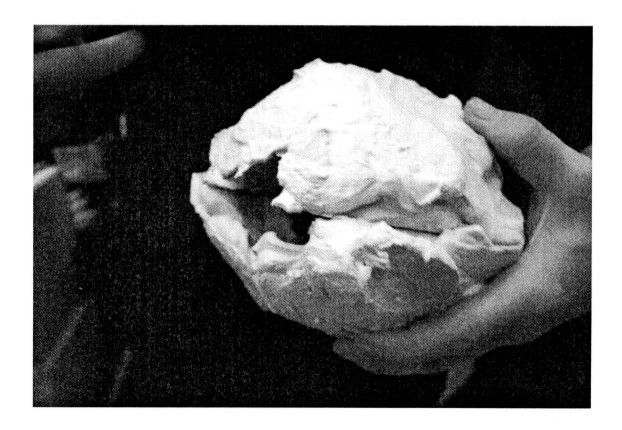

When the mold has fully cured, and I like to wait at least 24-48 hours before attempting this unless I feel really, really lucky that morning, it is ready to be greased up, re-assembled and charged up with the casting material.

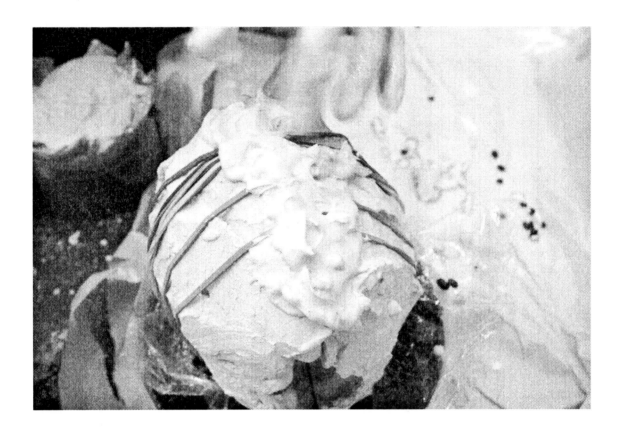

Place the two pieces of the mold together, and use a bit of wet plaster to seal the edges. Don't go obsessive over this, because you don't want to louse up the mold for another shot. What you want is to prevent the charging material from leaking out, that's all. I like to use large industrial-strength rubber bands to hold the pieces together before sealing the edges.

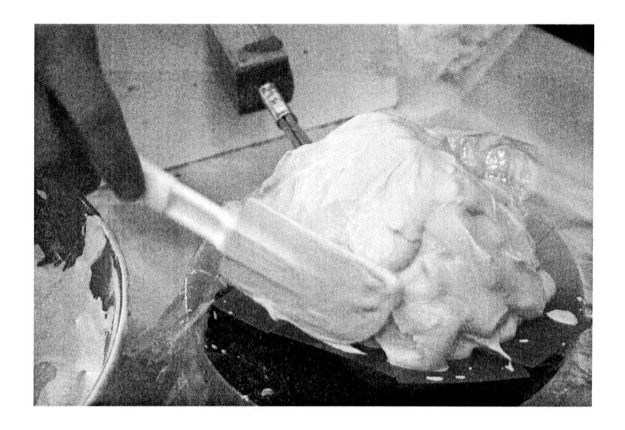

Now allow the plaster to begin to set, testing it gently from time to time to see how far along it has gotten, until it has the consistency of cold cream or yogurt. Now with the soft rubber spatula, begin to apply the plaster to one side of the piece. If the piece can be placed on its side, it will make it easier. I fill a large bowl with dry black beans and then place a piece of Saran Wrap on top, then lay the sculpture down on top of that for this process unless it's so large it can't go over on its side. If you're making a life-size six foot tall standing figure at this stage of your sculptural quest, you should seriously consider seeking professional psychiatric help.

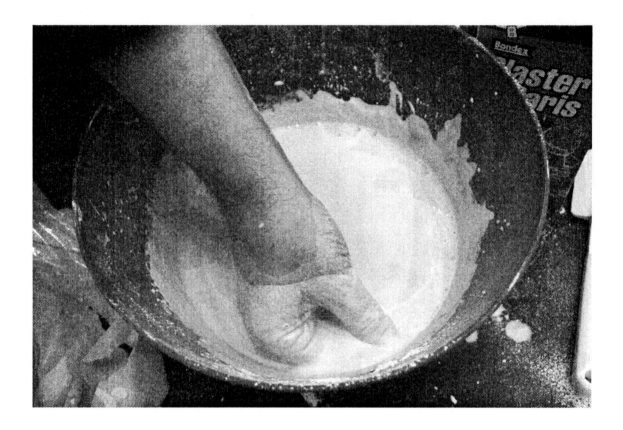

When the seal is somewhat dry, mix up your charging material, which can be anything from more plaster of paris to a compound cement such as HydroCal, HydroStone, Vatican Stone or anything you like as a final material for your casting. Don't mix up too much, or it will be wasted. Too little, and it's not going to work — you can't mix more and add it on, because it will result in a weak casting that will sooner or later break or collapse on you or worse, on an art client. I like to have a bit extra and a few smaller molds standing by to take up the excess.

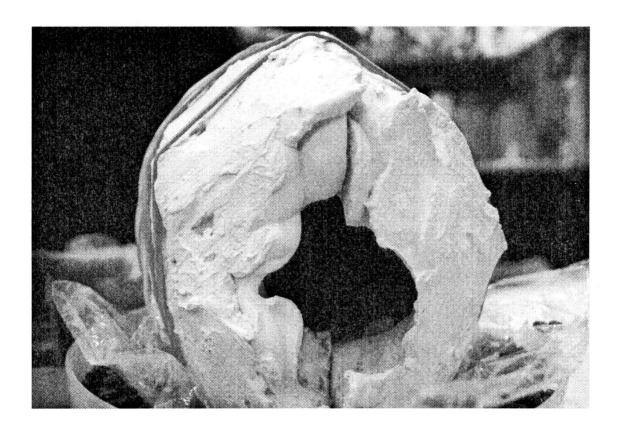

Be sure at this stage to not forget to insert your bolt head-first into the base of the casting, about 1 or 2 inches in. This will later be used to affix the sculpture onto its wood, onyx or marble base, so make certain the bolt is really at a 90 degree angle to your piece. You'll need something like a 1/4" continuous thread bolt, anywhere from 2 inches long to 4 inches long, depending on the size of the sculpture and the thickness of the base. For onyx, you might need a 6, 8 or 10 inch bolt, depending on what you have in mind for your base. The onyx or marble base will need to be pre-drilled and countersunk on the bottom accordingly, making certain to allow for "drift" so the piece sits correctly on top of the base. Experience will help you to figure this out, and there's nothing like a string of failures to give you the data you need.

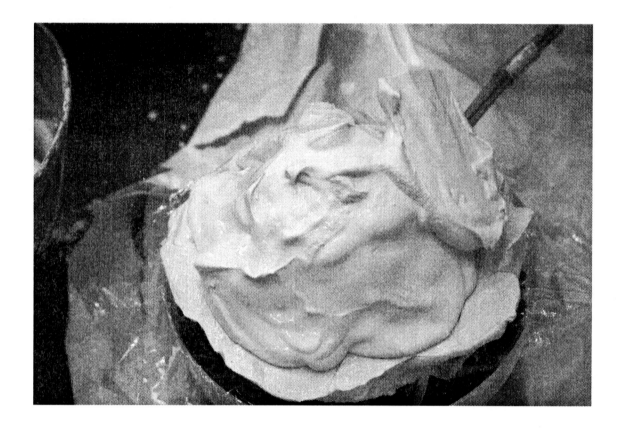

Now we wait once again. There's lots of waiting in sculpture, so you'll have an opportunity to practice your Buddhahood quite a bit. Tap on the exposed foot or base of the sculpture to determine whether or not it has cured sufficiently to crack the mold open. Feel it with your fingers to see if it's still cold, damp or soft. Be patient, this might take a few days.

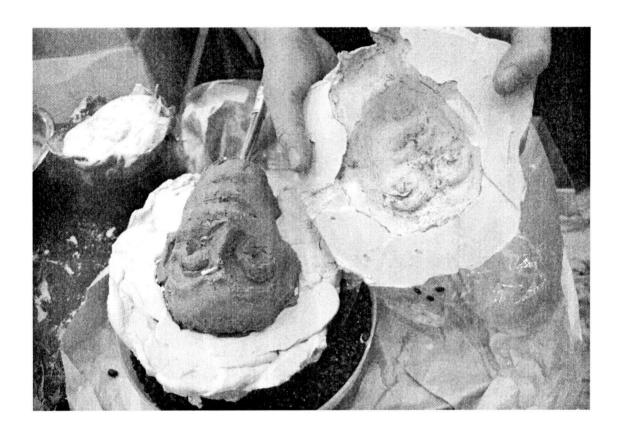

Using the same technique as before, crack the mold open, exposing the sculpture within. Your work has now actually just begun. You'll want to use several types of formed plaster rasps to finish the areas that are too high. Don't ever, ever use a rasp on wet plaster or HydroCal, or you'll be replacing rasps forever. The damp plaster sticks in the rasp between the teeth, and doesn't ever come out, making the rasp useless.

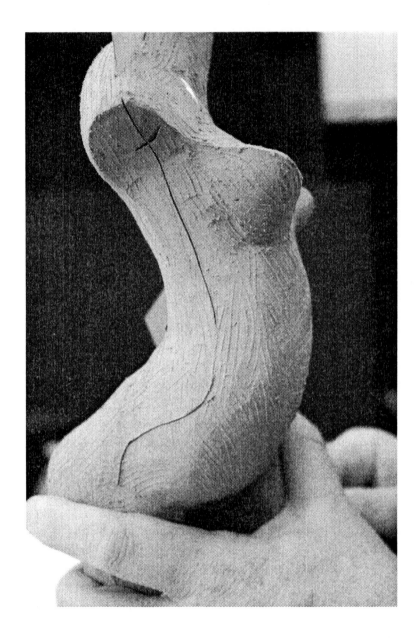

Now you might want to sand some areas, or chase the surface with some tooling to re-establish the surface you had in mind to begin with.

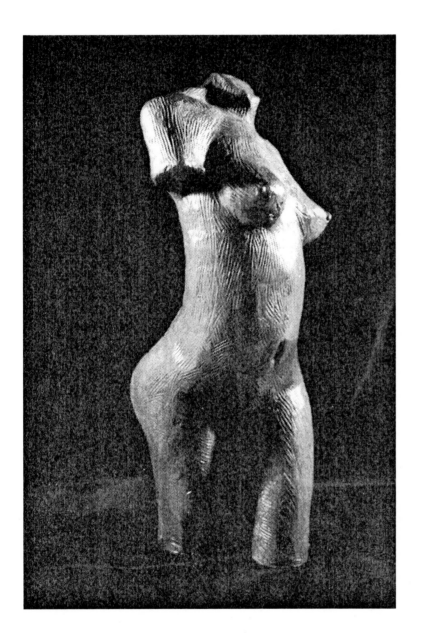

The Lost Nude

Then you're ready for the final finish, which might be coloring with acrylic or stain, or surfacing with bronze powder, or painting or indeed any of a thousand different methods of finishing a casting, followed by wax and hand-polishing or not as you choose. You might varnish or lacquer or varathane it or just leave it raw and exposed to wear and the elements; it's totally up to you — you're the artist and you must decide these issues.

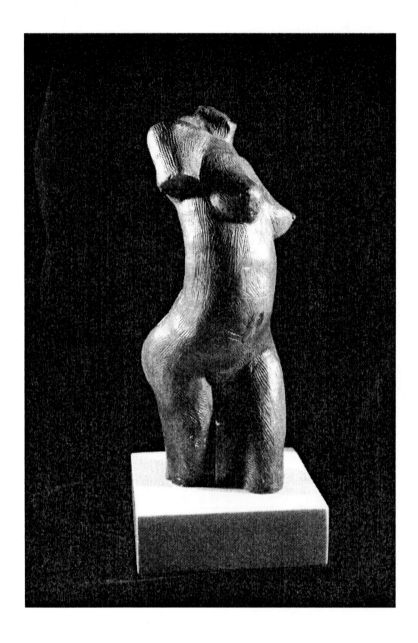

*The Lost
Nude*

Place your sculpture onto the base with the bolt you've inserted into it and lock it in place with a washer and nut, and you're done, except for the most important part; naming your sculpture and deciding on a fair and reasonable market price that you and your client can both agree on and live with.

And that's it, all you need to get started in the world of three-dimensional art. You're now well on your way to making Amazing Sculpture that You Can Do!!!

Dear Reader:

If you would like to contact the book's publisher for current information regarding art books and instructional art dvds please feel welcome to use the contact information below.

Gateways Books & Tapes
P.O. Box 370
Nevada City, CA 95959-0370

Phone: (800) 869-0658
　　　　(530) 271-2239
Fax:　　(530) 272-0364
Websites: www.gatewaysbooksandtapes.com
　　　　　www.hei-art.com

Titles available from
GATEWAYS FINE ART BOOKS

Draw Good Now
Mysteries of Still Life
Charcoal Nudes
Awesome Graphite Landscapes
Amazing Sculpture You Can Do

Pure Gesture
Miro's Dream
My Otis Experience
E.J. Gold at MoMA